CREATIVE WATERCOLOR WORKSHOP

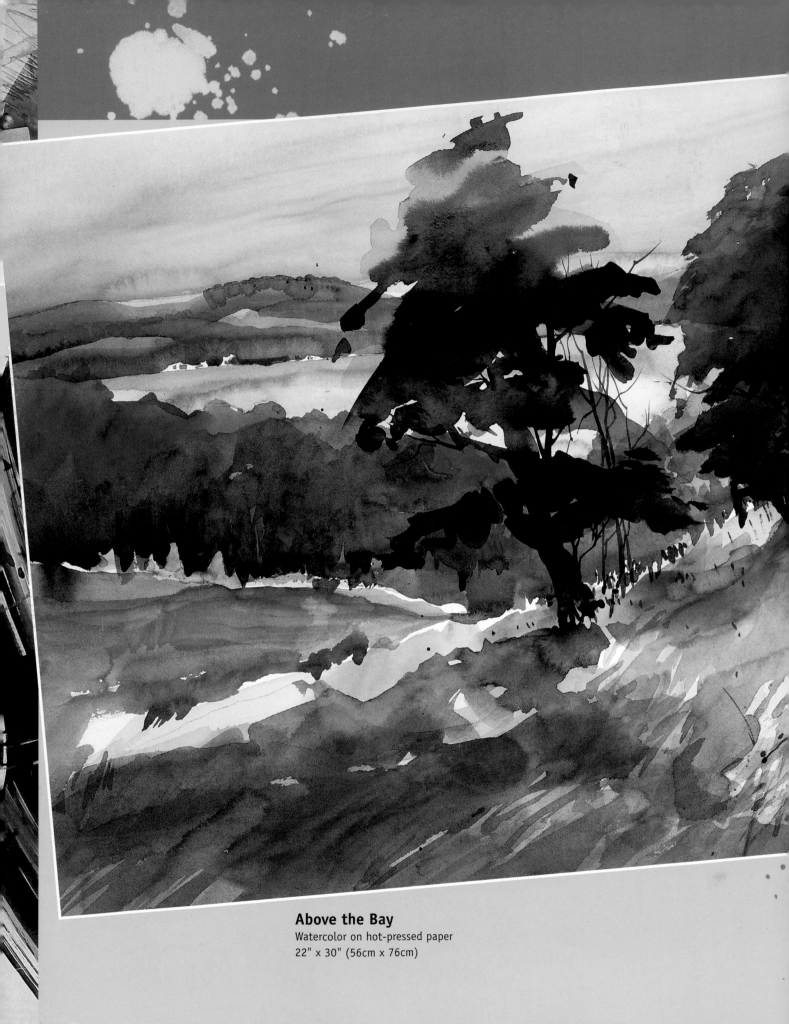

Above the Bay
Watercolor on hot-pressed paper
22" x 30" (56cm x 76cm)

CREATIVE WATERCOLOR WORKSHOP

Mark E. Mehaffey

NORTH LIGHT BOOKS

ork.com

Creative Watercolor Workshop. Copyright © 2005 by Mark E. Mehaffey. Manufactured in China. All rights reserved. No part of this book may be reproduced in any form or by any electronic or mechanical means including information storage and retrieval systems without permission in writing from the publisher, except by a reviewer who may quote brief passages in a review. Published by North Light Books, an imprint of F+W Publications, Inc., 4700 East Galbraith Road, Cincinnati, Ohio, 45236. (800) 289-0963. First Edition.

fw
F+W PUBLICATIONS, INC.

Other fine North Light Books are available from your local bookstore, art supply store or direct from the publisher.

09 08 07 06 05 5 4 3 2 1

Library of Congress Cataloging in Publication Data
Mehaffey, Mark E.
 Creative watercolor workshop / Mark E. Mehaffey.— 1st ed.
 p. cm.
 Includes index.
 ISBN 1-58180-532-2 (hardcover with wire-o binding : alk. paper)
 1. Watercolor painting--Technique. I. Title.
 ND2420.M45 2005
 751.42'2—dc22 2004020496

Edited by Stefanie Laufersweiler and Amy Jeynes
Designed by Wendy Dunning
Production art by Donna Cozatchy
Production coordinated by Mark Griffin

METRIC CONVERSION CHART

To convert	to	multiply by
Inches	Centimeters	2.54
Centimeters	Inches	0.4
Feet	Centimeters	30.5
Centimeters	Feet	0.03
Yards	Meters	0.9
Meters	Yards	1.1
Sq. Inches	Sq. Centimeters	6.45
Sq. Centimeters	Sq. Inches	0.16
Sq. Feet	Sq. Meters	0.09
Sq. Meters	Sq. Feet	10.8
Sq. Yards	Sq. Meters	0.8
Sq. Meters	Sq. Yards	1.2
Pounds	Kilograms	0.45
Kilograms	Pounds	2.2
Ounces	Grams	28.3
Grams	Ounces	0.035

About the Author

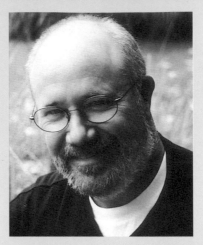

Nationally recognized artist Mark E. Mehaffey is a signature member of the National Watercolor Society, the American Watercolor Society, the Transparent Watercolor Society of America (master status), Watercolor West, and the Rocky Mountain National Watermedia Society, among others. Mehaffey has won major awards in juried exhibitions across the United States, including the Beverly Green Memorial Collection Purchase Award from the National Watercolor Society, the Arches Paper Company Award from the American Watercolor Society, the Grumbacher Gold Medal from Allied Artists of America, and the Skyledge Award from the Transparent Watercolor Society of America.

Mehaffey's work has appeared in many publications, most recently in *The Best of Watercolor* (Rockport Publishers, 1995), *Splash 5: The Glory of Color* (North Light Books, 1998), *Places in Watercolor* (Rockport Publishers, 1996) and *Creative Watercolor: Step-by-Step Guide and Showcase* (Rockport, 1995). Mehaffey's paintings are included in corporate, public and private collections, including those of BlueCross BlueShield and The Arches Paper Co. USA; the permanent collection of transparent watercolors at the Neville Public Museum of Brown County in Green Bay, Wisconsin; and the permanent collection of the Muskegon Museum of Art, Muskegon, Michigan.

Mehaffey is a retired public school art instructor who believes our art future is with the young, and he is dedicated to building that vision. Mehaffey is listed in *Who's Who in America* (2001) and *Who's Who Among America's Teachers*. He is a popular juror and gives workshops and lectures around the country. More information about Mark and his work can be found at www.mehaffeygallery.com.

A Rose for Rose
Watercolor on 140-lb. (300gsm)
cold-pressed paper
6$\frac{1}{2}$" x 8$\frac{1}{2}$" (17cm x 22cm)

Dedication

To Rosie, my partner and best critic.

Acknowledgments

The driving force behind this book is my wife, Rosie, who has supported me for the past thirty-four years while I have been putting brush to paper. We were married at the tender age of twenty; she liked my artwork then, and she is still my biggest supporter. Were it not for her, I would not have had the time or energy to create and this book would not have been possible.

My family deserves thanks for always being supportive. My dad was a dentist and an athlete, my mother was a nurse, and my sister is a dentist and my best patron. I was the odd one, the artist. Dad told me that whatever I chose to do in life, he would support my decision but that I had darned well better do a good job. It was good advice.

The friends I have made through teaching are part of the joy of life, and I sincerely thank all of my students. I spent a full and satisfying career teaching art in the public schools in Lansing, Michigan. I have taught thousands of students, from overactive kindergartners to the most serious college-bound high school students. Though I am retired, I continue to teach and share through my workshops. There is something special about the smile of a workshop participant experiencing a breakthrough.

I extend a big, heartfelt thank-you to the many wonderful artists who contributed paintings for this book; and a special thank-you goes to "The Watercolor Grapevine," the artists' discussion group to which I belong. Without each of these artist friends, this book would not have been possible.

I would also like to thank my editors, Stefanie Laufersweiler and Amy Jeynes. They both have the uncommon ability to make my ramblings make sense.

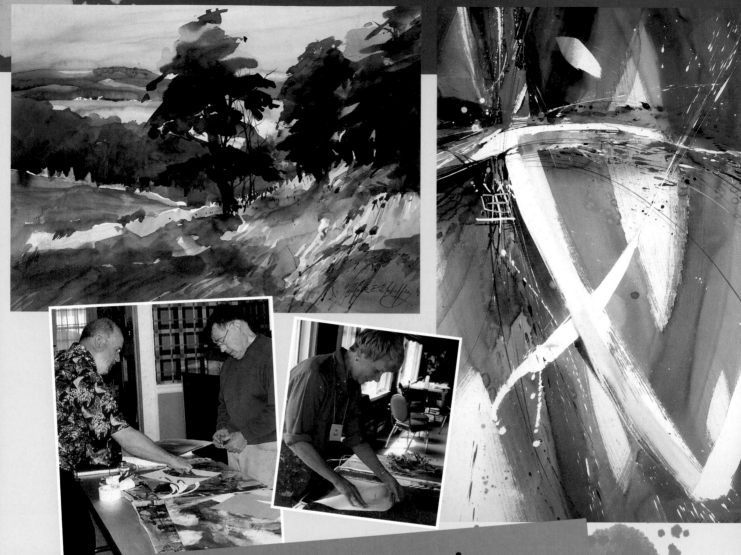

Table of Contents

1 Great Paintings by Design *16*

It's fun to dive right in and paint without planning, but only occasionally will that approach result in a great painting. If you want to paint to your full potential, keeping a sketchbook and developing your awareness of compositional issues will substantially increase your odds.

2 Tap Your Creativity *40*

Need a fresh approach to your favorite subjects? Try combining photo references, elevating an ordinary subject to something extraordinary, or painting an abstraction based on a realistic subject. Whatever your subject, make your painting communicate emotions and ideas that are important to you.

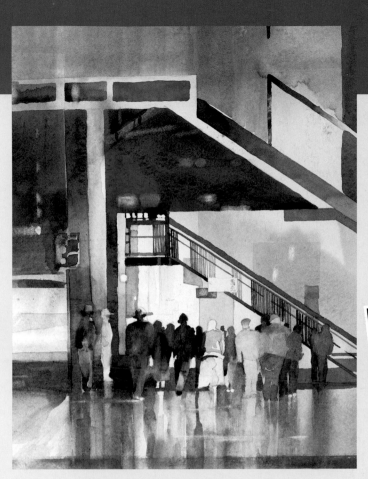

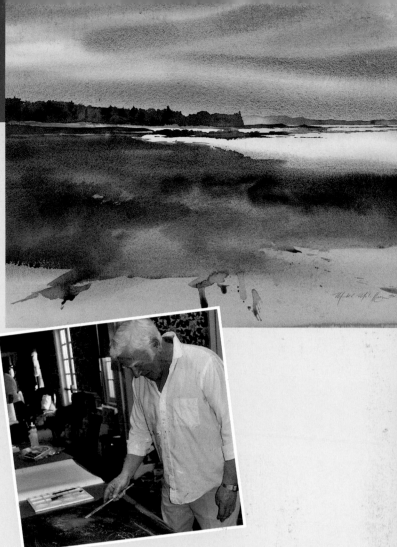

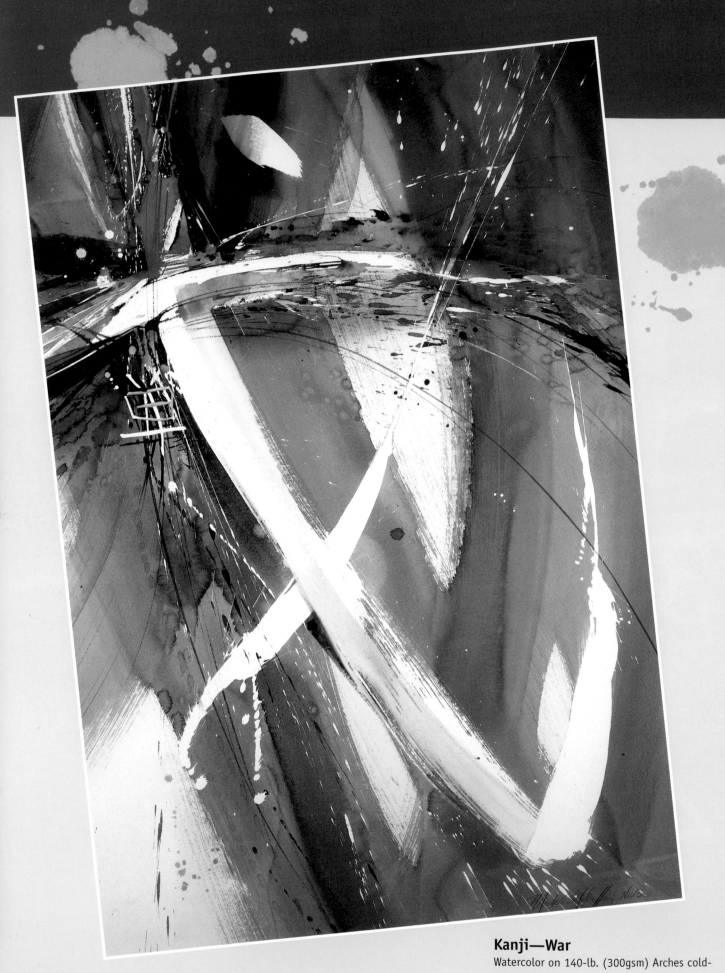

Kanji—War
Watercolor on 140-lb. (300gsm) Arches cold-pressed paper
44" x 29" (112cm x 74cm)

Introduction

Why write another book about painting? The answer is simple: I am a teacher. I have ideas that I believe will help artists. But this book is designed to get you to think about what you want to accomplish rather than to just follow along. This book will help you paint like you, not like me.

I've created tons of projects to get your creative juices flowing. You'll learn about technique, subject and content. Artists of all ability levels and philosophies should find something useful in this book, something to make them think or to make their next painting their best.

Most of the book is varied in its approach and fun. Don't get me wrong; I am very serious about art. The philosophies and techniques I offer are the result of over forty years of painting, study and contemplation. I have, however, given up taking *myself* too seriously.

No book can be all things to all painters, but if you want a review of design, a jump-start, or motivation to try a new technique, then this book is for you. What makes art interesting is the range of expression and the difference in philosophies; there really is room for all. This book covers a wide range of techniques, subjects and abilities. The art I've included from other contributors is exquisite. Read, paint along, grow, change, have fun. It is what we do.

9

Materials You'll Need

Shown here are the colors I used for the projects in this book, but part of the fun is deciding what works for you. Try these paints, try others, and then make your own artistic decisions about what you'll use.

Transparent Watercolor

This is the medium I reach for 90 percent of the time. My pigment drawers contain colors from many of the major manufacturers.

Gouache

Gouache is an opaque watercolor. Most manufacturers add chalk or white pigment to make their gouache opaque. M. Graham & Co. is one manufacturer that adds only a heavy pigment load to achieve opacity. Their gouache is finely ground with just the right amount of opacity.

Acrylics

When I want to significantly dilute acrylics, as when painting a wash, I use Golden Fluid Acrylics. They are designed to not break down when used in a "watercolor" fashion. I also use medium-viscosity Liquitex acrylics when I want a slightly thicker application of paint. When I really want to lay it on, I use Liquitex High Viscosity Artist Acrylic tube colors.

Sumi Ink

I do most of my sumi-e-style paintings with transparent watercolors on watercolor paper. That's all you'll need to do the sumi-e project in this book.

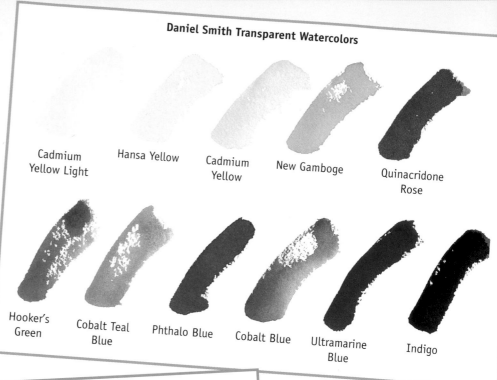

Daniel Smith Transparent Watercolors

Cadmium Yellow Light · Hansa Yellow · Cadmium Yellow · New Gamboge · Quinacridone Rose

Hooker's Green · Cobalt Teal Blue · Phthalo Blue · Cobalt Blue · Ultramarine Blue · Indigo

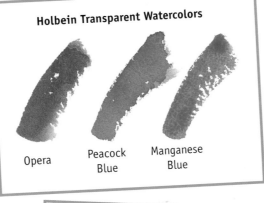

Holbein Transparent Watercolors

Opera · Peacock Blue · Manganese Blue

American Journey Transparent Watercolors

Skip's Green

Winsor & Newton Transparent Watercolors

Permanent Alizarin Crimson · Rose Dore · Winsor Red

M. Graham & Co. Gouache

| Azo Yellow | Cadmium Orange | Pyrrol Red | Dioxazine Purple | Ultramarine Blue | Phthalocyanine Blue |

Golden Fluid Acrylics

| Hansa Yellow Light | Hansa Yellow Medium | Titanium White over Turquoise | Transparent Red Iron Oxide | Turquoise (Phthalo) |

Winsor & Newton Gouache

Winsor & Newton white gouache over M. Graham & Co. Phthalocyanine Green

Liquitex Medium Viscosity Artist Acrylic

| Cadmium Yellow Medium | Bright Aqua Green | Ultramarine Blue | Raspberry |

Liquitex High Viscosity Artist Acrylic

| Naphthol Crimson | Ultramarine Blue | Phthalocyanine Blue |

Occasionally I use sumi ink with rice paper, and you may want to try that, too. Traditionally the ink used in sumi-e comes in stick form and is ground on a stone with water to liquefy it. The value is controlled by how much water is added. Buying the premixed liquid ink saves time.

Pastels

For me, working with pastel is simply fun—mostly because it's not my primary medium. I use it over watercolor washes. Watercolor paper accepts both transparent watercolor and any pastel an artist may choose to add. I rarely use pastels alone, but when I do, I use watercolor paper.

I have two kinds of pastels: hard and soft. My hard pastels are Prismacolor Nupastels. I use hard pastels for the beginning of a pastel painting when I don't want to overload the paper fibers with color. Sometimes I sharpen them and use them for detail work. To finish a pastel painting, I use Rembrandt soft pastels. As with all materials, experiment with many different brands to see what works best for you.

Colored Pencils

I use water-soluble colored pencils to add line and movement to nonobjective work. Colored pencils can add details that would be hard to render with a small brush. They give me the option of allowing a line to stay defined or blurring it with a water-loaded brush. I also use watercolor pencils in traditional watercolor paintings; sometimes that sharp point comes in handy. The brands I use are

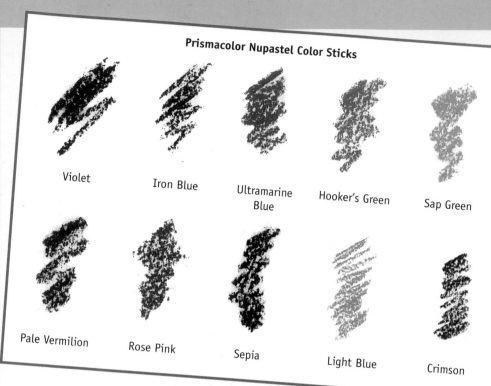

Prismacolor Nupastel Color Sticks

Violet Iron Blue Ultramarine Blue Hooker's Green Sap Green

Pale Vermilion Rose Pink Sepia Light Blue Crimson

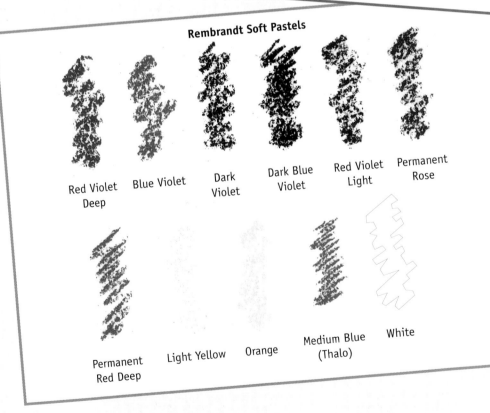

Rembrandt Soft Pastels

Red Violet Deep Blue Violet Dark Violet Dark Blue Violet Red Violet Light Permanent Rose

Permanent Red Deep Light Yellow Orange Medium Blue (Thalo) White

Koh-I-Noor, Cyklop Aquarell, Derwent and Prismacolor.

For the projects in this book that use colored pencil, all you need is a selection of colored pencils. I chose colors to either harmonize or contrast with colors already in the painting. Feel free to use any colors that you deem appropriate.

Watercolor Paper

Quality paper is very important. Poor-quality papers yield inferior results: Washes look muted; backruns are rampant. Make sure your paper is 100 percent cotton rag and pH neutral. Try a variety of brands, then use the ones that work for the way you paint.

The papers I use in this book are:

- **Arches Bright White 140-lb. (300gsm) hot-pressed**. I use this paper for mouth atomizer spray-painting and some sumi brush painting.

- **Arches Bright White 140-lb. (300gsm) cold-pressed**. I use this surface for glazing, negative painting and some landscapes.

- **Arches Bright White 300-lb. (640gsm) cold-pressed**. This paper has more tooth (roughness) than hot-pressed paper, but less than rough paper. I find I can apply many glazes on it. Paper of this weight does not always need stretching. If you are working wet on dry or doing extensive dry-brush applications, then stretching 300-lb. (640gsm) paper isn't necessary.

- **Arches Bright White 300-lb. (640gsm) rough**. This is currently my favorite surface. I use it for plein air painting and most of my florals, still lifes and landscapes. I also use it for wet-into-wet painting. It is a very forgiving surface. You can paint, wipe, scrape and texture to your heart's content without hurting it.

- **Fabriano Artistico Extra White 300-lb. (640gsm) rough**. This paper has a harder surface than the Arches version. Paint seems to sit on the surface longer, giving a bigger window of opportunity to make changes.

- **Crescent Watercolor Board Premium no. 5115, a hot-pressed board**. This watercolor board works very well for artists who do not like to stretch watercolor paper. Plus, the rigid board makes framing the painting easier.

- **Yupo synthetic paper**. This Japanese paper is made of plastic, so it is durable, archival and extremely smooth. It does not absorb water. The best way I can describe it is that it is like painting on glass. The paint sits on the surface and forms wonderful textures. It is very easy to make corrections and lift paint. On the other hand, layering and glazing are difficult, if not impossible. Blending an area that you like with another one that needs work is difficult. When you first try Yupo, don't give up on it too soon; try it again. I think you'll like it.

Gator Board

Gator board is a lightweight, rigid foamboard about $\frac{1}{2}$" (13mm) thick with a sturdy surface on both sides. It's great for stretching watercolor paper, and its light weight makes it very portable. I can stretch full sheets of paper on it many times before the staples wear holes in the surface. When that happens, I start using the board for half sheets.

Stretching Watercolor Paper

To stretch watercolor paper, soak it in lukewarm water. Allow seven to ten minutes for 140-lb. (300gsm) paper, more for 300-lb. (640gsm) paper. When the paper feels limp, it has soaked long enough. Pull the sheet out of the water and allow the excess water to drain off.

Now lay the wet paper on a piece of Gator board. Make sure there are no bubbles underneath the paper. Using a staple gun and $\frac{5}{16}$" (8mm) staples, work from the

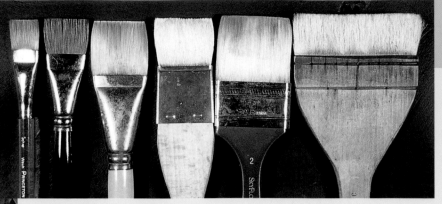

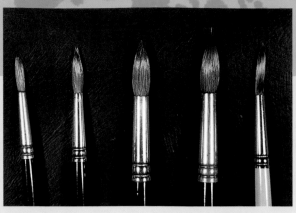

Basic Flats

From left to right:

- ³/₄-inch (19mm) nylon flat with a beveled plastic handle, useful for scraping.

- 1-inch (25mm) kolinsky sable.

- 1¹/₂-inch (38mm) Winsor & Newton series 680. This nylon brush is a favorite. It holds lots of pigment and is stiff enough to push thick applications of watercolor or acrylic.

- 1¹/₂-inch (38mm) hake with very soft hair.

- 2-inch (51mm) Robert Simmons Skyflow. The nylon bristles hold lots of liquid and are soft enough to not disturb underlying washes.

- 3-inch (76mm) hake with very soft pony hair.

Depending on the size of the paintings you plan to do, larger or smaller brushes of a similar hair or bristle composition may be appropriate. For my larger work I have flats up to 7" (18cm) wide!

Basic Rounds

These brushes are all kolinsky sable with the exception of the last one on the right. From left to right, the first four brushes are nos. 4, 6, 10 and 12. The last brush on the right is a favorite: a Cheap Joe's Golden Fleece rigger, no. 6. This brush comes to a nice point, holds lots of pigment and will paint a line a mile long—well, almost a mile!

middle of each edge to the corners and staple all the way around, spacing the staples ¹/₂" (13mm) from the edge and 1" (3cm) apart.

Allow the sheet to dry. A large fan will accelerate the process. You will end up with a perfectly flat painting surface that will resist buckling even if you apply lots of water.

Brushes

I am a "brushaholic." At last count I had well over a hundred brushes within reach of my drafting table! Certain ones are my favorites for a while, and then I discover new favorites. I use some brushes just for acrylics, others for gouache, and still others for transparent watercolor. I have a large selection of sumi brushes made with exotic hairs such as wolf, horse and goat.

My advice: Buy the best brushes you can afford. Pure kolinsky sable is the finest hair for transparent watercolor. It holds a lot of pigment and water and releases them in a predictable manner. However, there are many man-made fiber brushes that work almost as well and last much longer. Use the largest brush possible for the job, and experiment with shape and fiber to see what works for you.

Favorite Texture Makers

Pictured on the opposite page are some of my favorite textured items to drop into wet paint. As you paint, you will come up with your own favorites. I know artists who have boxes and boxes of texturing materials in their studios.

Spray-Painting Materials

For the spray-painting demonstration, I used the following items:

- **140-lb. (300gsm) hot-pressed watercolor paper, stretched, or hot-pressed Crescent Watercolor Board Premium no. 5115.**

- **Frisket film.** I've never tried other brands because this brand does exactly what I want: It protects the paper and cuts easily. Feel free to experiment. I have tried clear contact paper, which is less expensive but thicker and, therefore, more difficult to cut. You can purchase frisket film in sheets or rolls.

- **No. 1 craft knife with no. 11 blades.** Buy extra blades; they dull quickly, and you need a sharp blade to properly cut holes in the frisket film.

Bristle Scrubbers

For my scrubbers, I buy the most inexpensive bristle brushes I can find. Then I use a sharp craft knife to cut the bristles in half, making a very stiff brush capable of removing a lot of pigment from the surface of a painting. Pictured here are flats designed for oil and acrylic painting, trimmed as described above, in ¼-inch (6mm), ½-inch (13mm), ¾-inch (19mm) and 1-inch (25mm) sizes. Moisten the brush, gently scrub the shape you want to lighten, and lift the loosened pigment with a tissue.

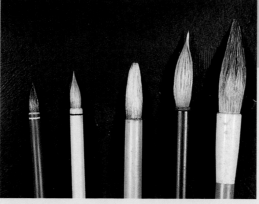

Sumi Brushes

For the sumi-e project in this book, I used regular round watercolor brushes. But I sometimes like to work with these Japanese and Chinese brushes for traditional sumi-e painting with ink on rice paper. You might want to try them, too. Left to right, the brush fibers are calf tail, goat, pony, goat and horse tail. The sizes are equivalent to nos. 4, 6, 10, 14 and 30 round.

I occasionally use my sumi brushes for watercolor painting. They hold a lot of liquid but tend to release it quickly. They do not possess the spring of a kolinsky sable, but sometimes that's a good thing.

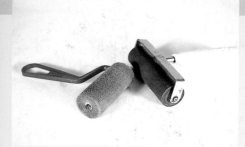

Roller and Brayer

For some of the demonstrations in this book you will need to apply textures with a brayer or a sponge roller. A brayer is a common printmaking tool used to ink a plate for printing. Sponge paint rollers of various widths can be purchased at hardware stores and from some art supply catalogs.

- **Baby-food jars.** Find a friend with a baby and get a supply of them. I use these to mix my liquid paint. Squeeze a dollop of tube watercolor into the jar and fill the jar with water. Put the lid on (make sure it's tight), then shake to mix.

- **Mouth atomizer.** This is an inexpensive tool for spraying liquids. Open it and make sure the ends fit together. Hold the narrow end in a jar of paint and blow hard through the wide tube. As you blow, you reduce the air pressure in the small tube. Paint shoots up the tube and your breath atomizes it. An atomizer throws a spray path about 12" (30cm) wide when held 18" (46cm) to 24" (61cm) away from the paper. Each mouth atomizer is unique as far as the amount of breath required and the dot size it throws. Experiment on a scrap piece of paper before starting a painting.

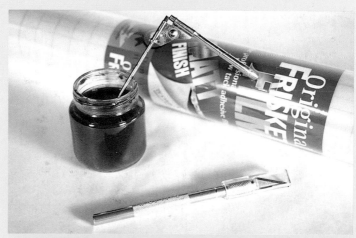

Spray-Painting Materials

Among the items I use for spray-painting are baby-food jars (for mixing paint), a mouth atomizer, frisket film, and a craft knife (to cut the film).

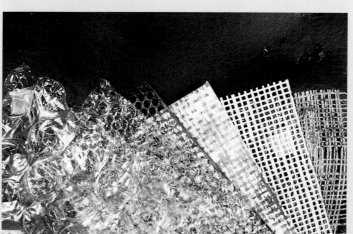

Favorite Texture Makers

From left to right: Bubble Wrap® with large and small bubbles, Mylar® ribbon with holes, textured mat board, needlepoint canvas and burlap.

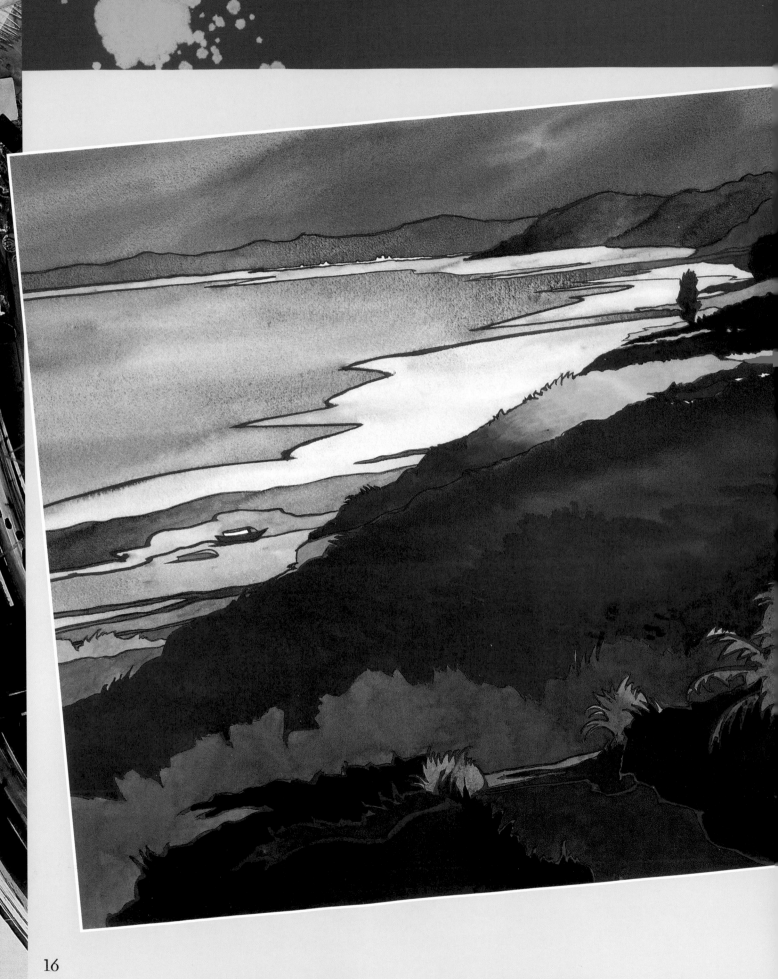

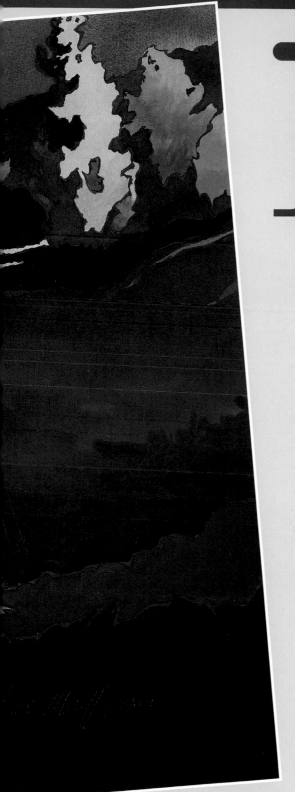

1 Great Paintings by Design

During my long teaching career, I have seen many issues that prevent painters from creating good paintings. One that pops up frequently is lack of planning. Most of us are eager; we want to pick up our brushes and dive right in. That way of working is great fun, but only occasionally will it result in a great painting. If you want your paintings to reach their full potential, keeping a sketchbook and developing your awareness of compositional issues will substantially increase your odds.

Shoreline, North
Watercolor on 300-lb. (640gsm) rough paper
22" x 30" (56cm x 76cm)

Sketch Before You Paint

We all want successful paintings. Using your sketchbook to set up that success is a great place to start. Always carry a sketchbook with you. Your sketchbook can be filled with small, quick sketches done on location during your travels, or it can be a journal, combining notes with small memory-jogging sketches. Your sketchbook may be where you record any visual idea that happens to pop into your head. As you try it, you'll develop your own favorite method of planning and sketching.

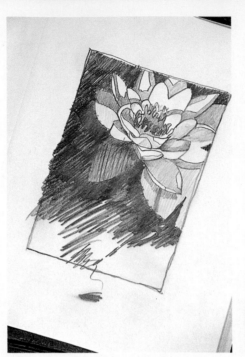

Water lily sketch (see facing page for the finished painting)

Sketches of Saginaw Street (Lansing, Michigan) in winter

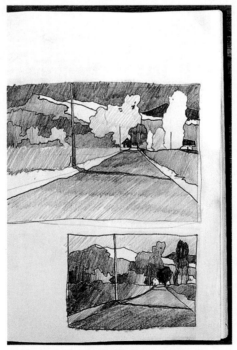

Different value plans for a country road painting (see facing page for the finished painting)

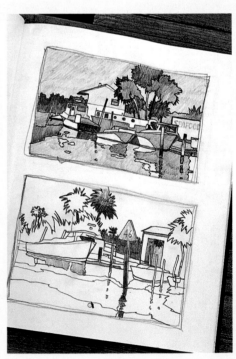

Sketches from Florida Everglades trip

18

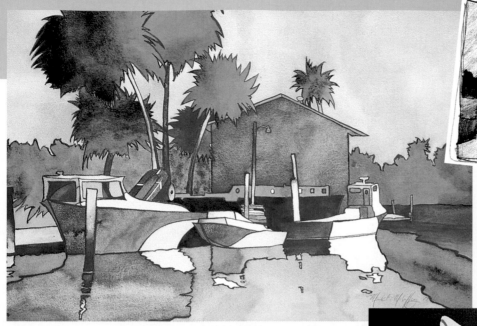

Work Boats
Watercolor on Arches Bright White 300-lb.
(640gsm) rough paper
22" x 30" (56cm x 76cm)

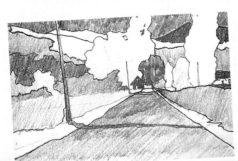

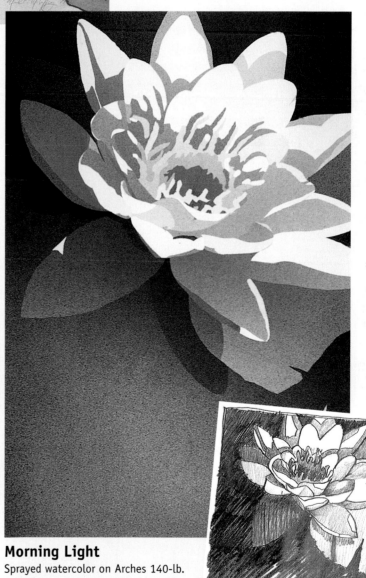

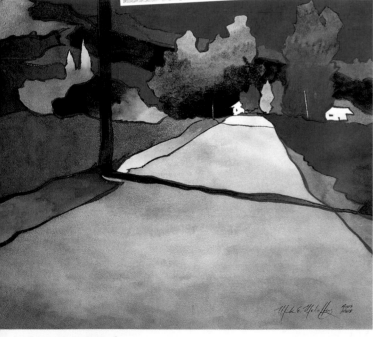

Country Road
Watercolor on Arches Bright White 300-lb.
(640gsm) rough paper
22" x 30" (56cm x 76cm)

Morning Light
Sprayed watercolor on Arches 140-lb.
(300gsm) hot-pressed paper
29" x 22" (74cm x 56cm)

Exciting Division of Space

Effective division of the picture space is key to making a painting that captures viewers' interest. That's true for any painting: landscape, still life, portrait or abstract.

The Rule of Thirds

You can create exciting divisions of space by placing the major horizontal and vertical lines in your painting so that they divide the picture space into unequal shapes. Asymmetrical shapes generate excitement; symmetrical ones create visual boredom.

So, if you're painting a landscape, avoid putting the horizon line exactly halfway between the top and bottom edges of the paper. Instead, try placing it one-third of the way down from the top or one-third of the way up from the bottom. The same goes for vertical lines: place strong vertical elements not at the center but left or right of center.

Once you've planned your asymmetric placement of vertical and horizontal lines, try placing important shapes in your composition at or near a spot where those lines intersect.

This principle is called the "rule of thirds." Use it consistently to plan your paintings, and see how much more interesting your compositions become.

Ho-Hum Horizon
Placing the horizon line in the center of a picture divides the picture space into boring, equal-size shapes.

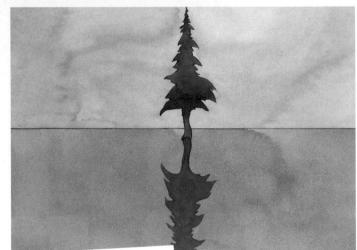

Dull Central Placement
Here, a strong vertical element placed dead center creates uninteresting left-to-right symmetry.

The Rule of Thirds
The overlaid grid lines divide this sketch into thirds both vertically and horizontally. My dominant vertical and horizontal elements fall roughly along the grid lines. The lower-left intersection of lines becomes my focal point. The lone figure is tiny, yet the viewer's eye finds it easily.

The Rule of Thirds in Action

Look at these paintings from my files to see what a difference effective division of space makes.

Static Division of Space

This work clearly shows a static and boring division of space. The dark shape of the foreground, which in this case runs the whole length of the painting, splits the picture space exactly in half diagonally.

Canyon Sun
Watercolor on Yupo
26" x 40" (66cm x 102cm)

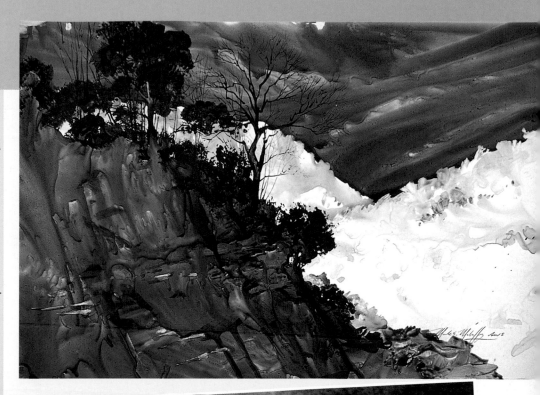

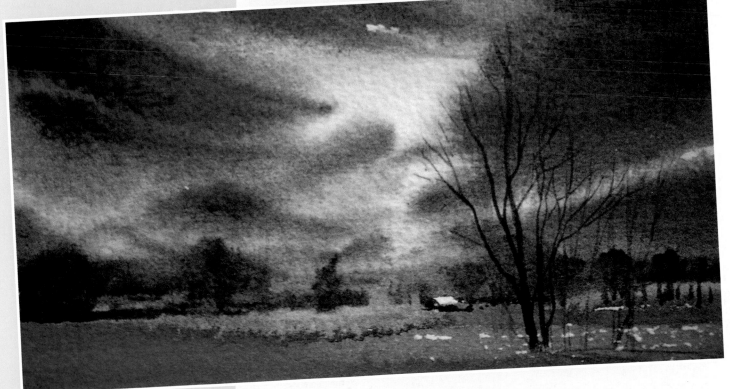

Uneven Rectangles Create Drama

A very low horizon divides the picture space into two uneven rectangles and clearly communicates what part of the scene is most important: the sky.

Switzer Farm
Watercolor on Arches 140-lb. (300gsm)
cold-pressed paper
9" x 13" (23cm x 33cm)

Organic vs. Geometric Shapes

One way to add both unity and excitement to a painting is to let one kind of shape—either organic or geometric—dominate.

Organic shapes are the shapes of nature, such as leaves and flowers, rocks and clouds. They are irregular or even amorphous.

Geometric shapes, on the other hand, are based on mathematical computations and aren't often found in nature. Most man-made objects fall into this category; for example, buildings are usually made up of squares and rectangles, and a coffee mug is a cylinder.

The images on this page are simplified examples to get you thinking. You don't have to use only geometric or only organic shapes for an entire painting; just let one or the other dominate. On the facing page are several finished paintings that really show the power of this compositional approach.

ACHIEVE UNITY THROUGH DOMINANCE *The principle of dominance is a great way to make a stronger visual statement in your paintings. Dominance is a theme you'll encounter repeatedly in this chapter. It can be applied to shape (as explored on this page), value (page 28), color (page 30) and color temperature (page 31), among other features. Dominance in a composition holds the image together and gives the viewer a clue as to what's important to you about the subject.*

A Confusing Mix of Shapes
This example is half organic and half geometric shapes. Neither kind of shape dominates; the painting seems to have no focus.

All Organic Shapes
The organic shapes in this simplified composition remind me of rocks in a riverbed. The similarity of shapes lends unity.

All Geometric Shapes
These geometric shapes resemble cut paper scraps dropped on a table. You might enjoy doing a nonobjective work that entails manipulating geometric shapes.

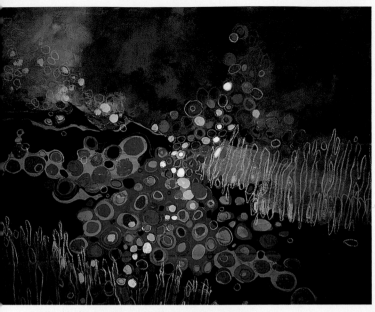

Organic Forms Communicate a Concept
Strong colors and the predominance of circles and other organic shapes make this work pulse with life.

Life in Vermilion
Susan Webb Tregay
Watercolor on 300-lb. (640gsm) cold-pressed paper
22" x 30" (56cm x 76cm)

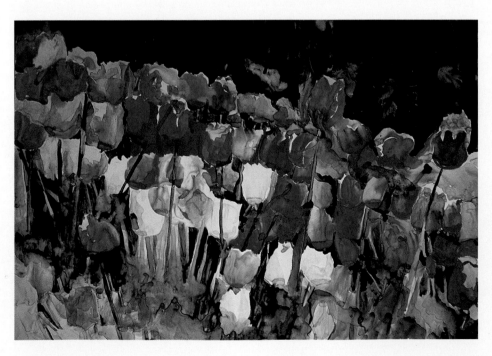

**Geometry
Creates a Dynamic Feel**
This painting contains some organic shapes, but rectangles, circles and triangles take the lead.

Take #10
Robert Lee Mejer
Watercolor
30" x 22½" (76cm x 57cm)

Repeated Organic Shapes Spark Movement
The repetition of the tulip shapes dances your eye from one side of this colorful composition to the other.

Stained Glass Garden
Pat Fortunato
Watercolor
22" x 30" (56cm x 76cm)

Find the Focal Area

One of the first things you should ask yourself when setting up to paint is, "What is it about this subject that really makes me want to paint it?"

For example, imagine you're about to paint a still life. Maybe you are drawn to the objects sitting on the table. But maybe what really excites you is the colorful fabric the objects are resting on. Perhaps you love the reflections in a glass vase, or maybe the objects have some personal meaning in your life. Once you decide what is most important, the proper focal point of your painting will be evident.

Looking at the paintings on this page, can you tell what each artist thought was most important and how he or she communicated that to the viewer?

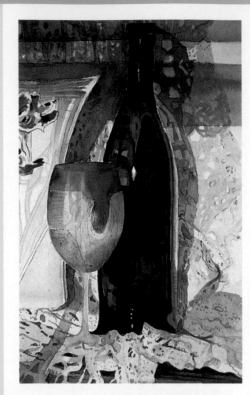

Color Contrast Attracts Attention
This artist defines the focal area with the strongest possible color contrast, that of complementary colors. We immediately look at the orange wineglass and its companion blue bottle.

Blue Triad
Pat Fortunato
Watercolor on Waterford Saunders 200-lb. (425gsm) cold-pressed paper
17" x 11" (43cm x 28cm)

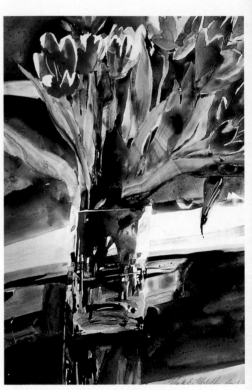

Strong Value Contrast Emphasizes the Focal Area
I quickly exeuted this painting after seeing the wonderful reflection of a glass vase on a glass table. The strong color of the tulips acted as a perfect foil to the value contrasts within the reflective surfaces.

Red Tulip Reflection
Mark E. Mehaffey
Watercolor on Yupo
30" x 22" (76cm x 56cm)

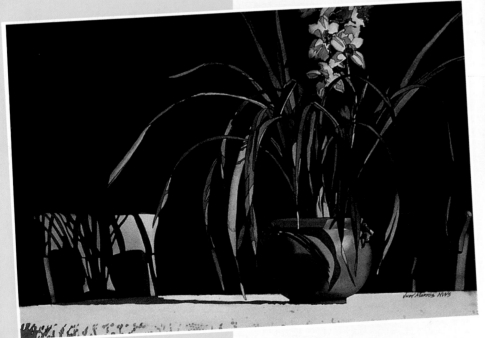

Aunt Edna's Roseville Vase
Judy Morris, AWS/NWS
Watercolor on Arches 300-lb. (640gsm) cold-pressed paper
21" x 29" (53cm x 74cm)

Dramatic Light Points the Way
This may be a painting of a vase, but the most important players in this work are light and shadow. The path of light leads the viewer's eye to the shadows on the chair. The strong value contrasts created by those shadows further reinforce that area as the focal point.

Lead the Viewer's Eye With Value

Beginning artists tend to use lines to define everything rather than using color and value. But if a painting is going to be convincing, value needs to be a major consideration in telling the visual story. In real life, we perceive edges—where one object ends and another begins—mainly by observing value contrasts.

Five Basic Values

The real world has an infinite number of values between the lightest (white) and the darkest (black). In painting, it is very helpful to limit your value selection to five basic values: white, light, medium, medium dark and dark (or black). This forces you to simplify what you see in the natural world. Then you can begin to assign values in your painting based on the artistic needs of the work rather than letting the values be dictated by what you see. That's one of the first steps in becoming not just an observer but an artist.

Use Value Contrast to Lead the Viewer

You can direct the viewer's eye toward your focal point by using value contrast. Black next to white is the greatest possible value contrast. Try this experiment with the diagram at right: Quickly look at the entire image, and think about which side your eye was drawn to first. You probably looked first at the shape on the bottom, which has a high degree of value contrast. You can use this principle in your painting to compel the viewer to look at the part of the painting that's most important to you.

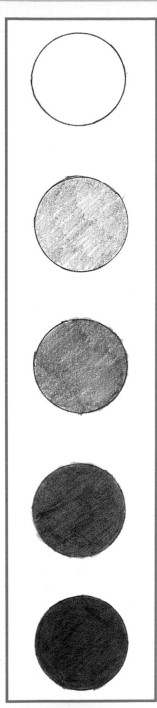

Simplify Your World to Five Values
When you paint, don't try to duplicate the infinite range of values in the natural world. White, light, medium, medium dark and dark (or black) are all the values you need.

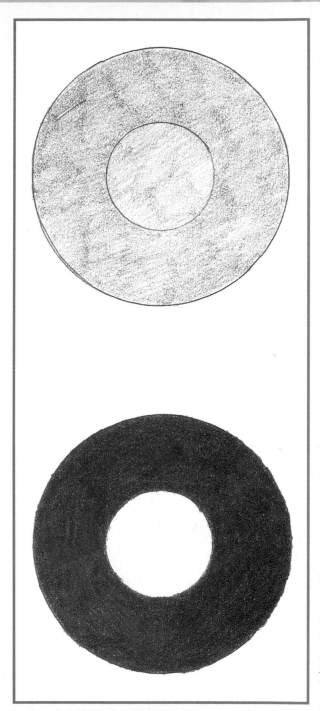

The Power of Value Contrast
Which of these targets draws your eye first? The one on the bottom—it has a higher degree of value contrast.

Create a Value Plan

Once you have decided how to divide the picture space (page 20) and determined which kind of shapes will dominate (page 22) and where you'll place your focal point (page 24), you can begin to assign values to the shapes in your composition.

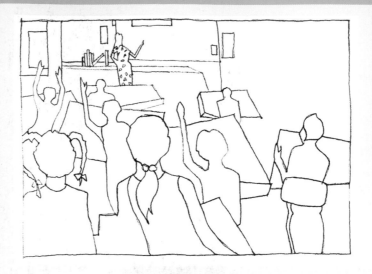

1 Outline the Shapes

Starting with your focal area, outline each shape. In this plan for a painting of students in a classroom, my focal area is the teacher standing at the blackboard.

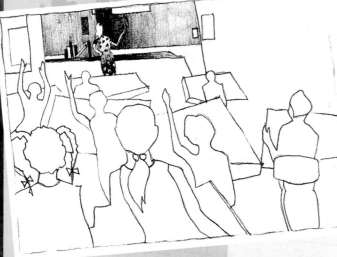

2 Assign Values to the Focal Area

Next, assign values to the focal area. Since you want this area to draw the viewer's attention, give it high value contrast by placing a very dark value next to a very light value (or white). Shade in the values with a soft no. 5B or 6B pencil. Here, I've left the teacher's hair unshaded (the white of the paper) and assigned a very dark value to the adjacent blackboard shape.

VARY YOUR VALUE PLAN

I recommend assigning your darkest dark and your lightest light to the focal area to create a maximum amount of value contrast there. But don't get into the habit of making the focal area the only place you use your darkest darks and your lightest lights. Doing that creates a spotlight effect. Sometimes that works, but most often you need a varied value plan to move your viewer's eye around the painting.

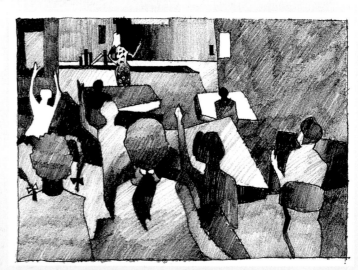

3 Assign Values to the Remaining Shapes

Working your way out from the focal area, assign a value to every other shape. Most of the composition should have a lesser degree of value contrast than that you created in the focal area. Think in terms of each area's importance to your visual story. Near the edges of your composition, you will have some shapes with very little value contrast, as is apparent along the bottom edge of this sketch.

Now Do Another

After you have done all the hard work of creating a value plan, sometimes it's helpful to do it again! When you have two plans to look at, usually one of them will strike you as the stronger choice.

One way to create an alternate value plan is to start with the same arrangement of shapes as in your first plan and then assign a different pattern of value contrast within your focal area. You could reverse the order of darks and lights or just alter the relationships enough to get a different look.

Assign values to the remaining shapes based on the redone focal area. Some of the values will differ from those in your first version; some will not. You now have two value plans which may be slightly or very different. One of them will probably jump off the page at you, begging to be painted!

WHEN LESS CONTRAST IS BETTER *Sometimes the stark contrast of white against a very dark value is too much for a particular painting. Examples are a purposely high-key or low-key work (a concept we'll look at on page 28) or a painting in which atmospheric conditions like dawn, dusk, rain or fog create ambiguous lighting. In such a case, the maximum amount of contrast in the painting won't be as extreme as white against a very dark value, but the painting's greatest degree of contrast should still fall in the focal area.*

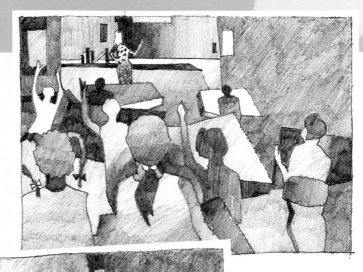

Value Plan for Classroom Painting, Version One

Value Plan for Classroom Painting, Version Two

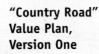

"Country Road" Value Plan, Version One

"Country Road" Value Plan, Version Two

27

Set the Mood With Value and Color

The mood of a painting is set largely by two factors: value and color intensity.

Value Choices and Mood

When assigning values to your composition, you can let the value choices span the entire value scale of white to black, or you can weight your choices to favor one part of the value scale.

- **High-key paintings** favor the light end of the value scale. The painting's darkest dark may be a middle value.

- **Middle-key paintings** have a preponderance of middle values and few, if any, strong lights and darks.

- **Low-key paintings** have more medium darks and darks but very few lighter areas. A midtone may be the lightest light.

Examine the mood created by the value choices in each of the paintings on this page. When you paint, try selecting a value range that will create the mood you want to convey.

Low Key
This dramatic painting has just enough light to convey a mystical feeling.

Beneath the Darkness in the Quiet Waters
Mary Ann Beckwith
Watercolor on Arches 140-lb. (300gsm) cold-pressed paper
22" x 30" (56cm x 76cm)

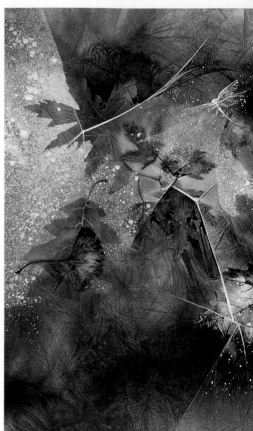

High Key
The preponderance of upper-middle and light values suggests blazing noonday sun.

Proud Iris
Peggy Flora Zalucha
Watercolor on 240-lb. (504gsm) Arches rough paper
20" x 46" (51cm x 117cm)

Middle Key
Here, middle values hold the lights and darks together, and the color choices help convey the feel of the season.

Autumn Frost
Kathleen Conover
Watercolor on Arches 140-lb. (300gsm) cold-pressed paper

Color Intensity and Mood

As a painter you can also set the mood by varying the intensity of the color. The finished paintings on this page show the vastly different emotional responses created by neutralized and saturated colors. (See page 31 for more on neutralizing colors with complements, and try it yourself in the project on page 32.)

Value Contrast Creates Interest Within a Simple Palette
The palette of primary colors is simple, but the wide-ranging values create areas of cheerful light and moody shadows.

Cattleya Forms
Robbie Laird
Watercolor
18" x 30" (46cm x 76cm)

Bold Colors Stir a Passionate Response
Thanks to the highly saturated colors and the complementary pairing of fiery orange and intense blue, this painting is almost impossible to feel "neutral" about.

Circumsolar
Robert Lee Mejer
Watercolor, graphite and crayon on Arches
300-lb. cold-pressed paper
30" x 22½" (76cm x 57cm)

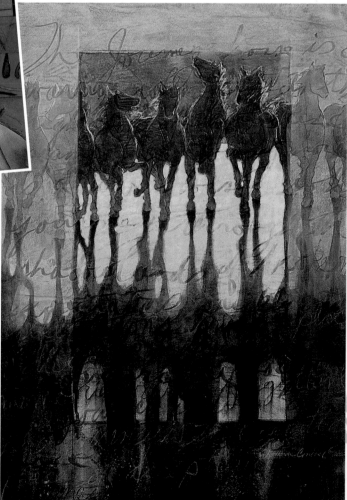

Neutrals Evoke a Dreamlike Mood
Viewing these horses and graphical elements rendered with a palette of neutrals is like trying to recall a fleeting image from a dream.

Journey Horse Series, Dream Runner
Kathleen Conover
Watercolor on Arches
140-lb. (300gsm)
hot-pressed paper

Choose a Color Scheme

The color combinations in a painting can be a very personal choice for the artist and a personal experience for the viewer. Here are some common and not-so-common color combinations you can try.

Analogous, Nothing Dominant. One of the safest color schemes is an analogous scheme, in which all the colors are adjacent on a color wheel (example: yellow-green, green and blue-green). Analogous schemes automatically possess color unity.

Analogous, One Color Dominant. To make an analogous color scheme work for you, you might let one of the colors be dominant. The dominant color will hold the other hues together and help the viewer focus on whatever is most important in your painting.

Analogous Plus Complement of Dominant Color. To add excitement, try an analogous scheme with the addition of the dominant color's complement (the color in the opposite position on a color wheel). Since complements placed next to each other tend to "vibrate" and draw attention, it makes sense to add the complement in or around the painting's focal area.

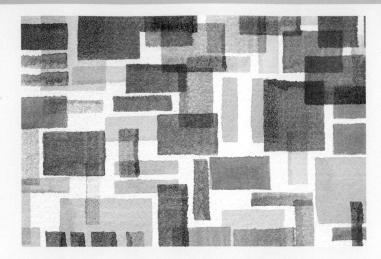

Analogous, Nothing Dominant
This scheme is unified and safe, but nothing about it catches the eye.

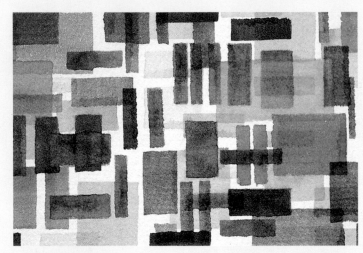

Analogous, One Color Dominant
The dominant green provides something to focus on and holds all the colors together.

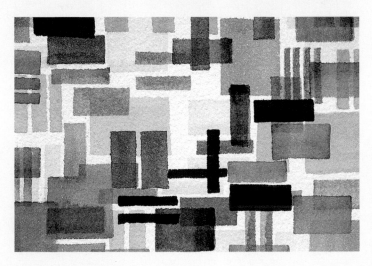

Analogous Plus Complement of Dominant Color
Here, green dominates the related colors yellow-green and blue-green. Adding red, green's complement, creates interest and excitement. All that green really makes the red accents pop!

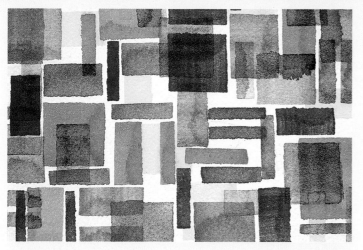

Three Pairs of Complements, Nothing Dominant
This is an interesting scheme, but the overall effect is confusing.

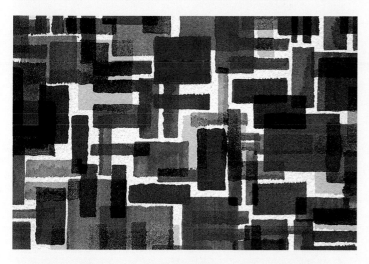

Three Pairs of Complements, One Hue Dominant
The many complementary hues look less jumbled if one hue is allowed to dominate.

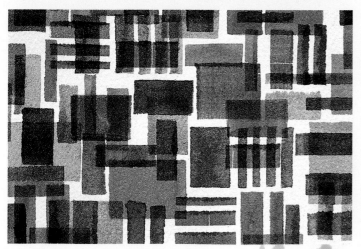

Neutrals and Neutralized Colors, One Temperature Dominant
These neutrals and neutralized colors are held together because the cool colors dominate.

Three Pairs of Complements, Nothing Dominant. This is a tricky but interesting scheme. For example, you could use the primaries blue, red and yellow with their complements orange, green and violet. A scheme with this many colors can quickly become a confusing jumble.

Three Pairs of Complements, One Hue Dominant. To make three pairs of complements work, let one hue dominate so that it can hold the work together.

Neutrals and Neutralized Colors, One Temperature Dominant. Mixing complements in equal or nearly equal amounts (see the sidebar on the facing page) produces a neutral. Mixing a color with a smaller amount of its complement produces a neutralized or toned-down version of the base color.

A scheme of neutrals and neutralized colors is very effective for landscapes when conditions such as mist or rain make colors look muted. Because this color scheme doesn't use pure, intense colors, it's harder to let one specific color dominate. One solution is to use a dominant color *temperature,* either warm or cool. That will hold everything together.

MIXING COMPLEMENTS TO GET NEUTRALS *Mixing complements in equal proportions theoretically creates a neutral. In reality, the results depend on the relative strength of the pigments used. For example, if you mixed Phthalo Green, a very strong pigment, with any red, you'd have to use a greater proportion of red to get a truly neutral result.*

Paint a Moody Landscape With Neutrals

Some dismiss neutrals as "mud," but they can be beautiful. Warm and cool grays are great for setting the mood in a landscape painting. Contrasting more-intense pigments against neutrals, as in this demonstration, can really make a painting sing!

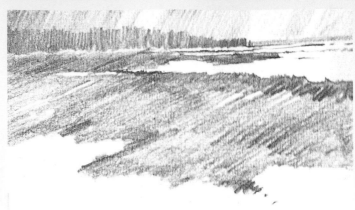

1 Value Study
This is an east-facing view of early morning at one of my favorite fishing spots. At this stage, simplify the shapes of the landscape. This will allow you to concentrate on using color to create mood instead of being distracted by small shapes or myriad details.

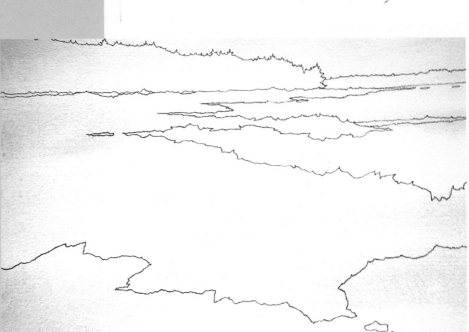

MATERIALS LIST

WATERCOLORS
Cobalt Blue ✂ New Gamboge ✂ Quinacridone Rose

PAPER
300-lb. (640gsm) rough, 11" x 15" (28cm x 38cm)

BRUSHES
½-inch (12mm) and 1½-inch (38mm) flat ✂ Nos. 6 and 8 round

OTHER MATERIALS
No. 2 pencil

2 Do the Underpainting, Then Sketch
On your palette create a violet using Cobalt Blue plus a small amount of Quinacridone Rose. Neutralize the violet by adding a little New Gamboge, violet's complement. Pull aside part of this mix and alter it slightly by adding either New Gamboge (for a warm neutral) or Quinacridone Rose (for a cool neutral).

Using a 1½-inch (38mm) flat, cover the entire paper surface with water. Apply washes using both of the color mixtures on your palette, avoiding any areas you want to keep white or very light. Allow this underpainting to dry completely.

Use a no. 2 pencil to lightly outline your shapes right on top of the dry underpainting. For this demonstration I used very heavy pressure so that you can easily see every shape. However, you may prefer to use lighter pressure so that your pencil lines won't show.

3 Establish the Sky Shape

Pre-wet the sky and headland area and wait for the shine to just disappear. Then, working from the top down, lay in the sky and headland with mixtures of New Gamboge, Quinacridone Rose and Cobalt Blue. Be sure to bring the sky colors right down over the headland; that way, when you add color to the headland later, it will appear to be in front of the sky shape.

Using the same colors, add an indication of clouds.

4 Working Forward, Paint the Headlands

After the sky, the distant headland is the next closest shape. Paint that shape using a light-value mixture of New Gamboge and Quinacridone Rose, adding a small amount of Cobalt Blue as you approach the edge of the paper.

Next, paint the closer headland with a slightly darker mixture of the same colors. Try to vary the temperature from cool to warm and back again as you move from left to right. You may wish to add a touch of intense, very saturated pigment for the last pine tree at the end of the headland. This will become the focal area and is an appropriate spot for more-intense color.

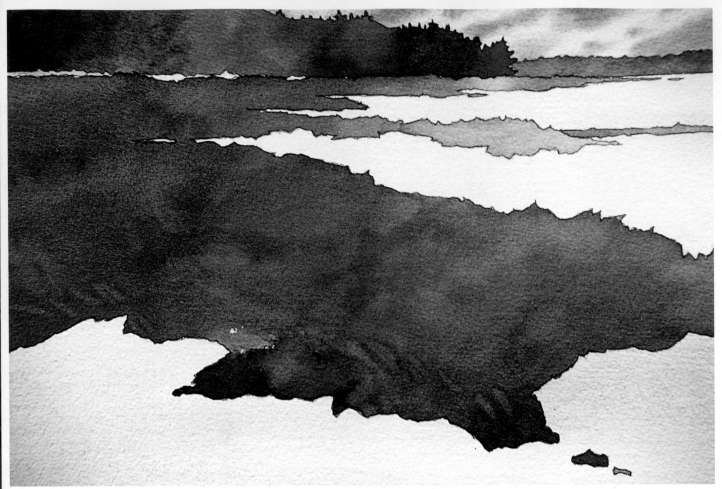

5 Paint the Large Land Mass

Create mixtures of Quinacridone Rose and New Gamboge on your palette, varying the temperature of the mixtures by adding more or less Quinacridone Rose or a little Cobalt Blue. Be sure to mix a large amount of paint so you will have enough to cover the shape that runs from the distant middle ground all the way to the foreground.

Paint in the large land mass using a no. 8 round. This large brush carries lots of water and pigment, which will make it easier to cover a large shape, and it has a small enough point to help you follow the sometimes complicated outline. Allow more of the New Gamboge to show in the wash as you paint the smaller islands that are closer to the focal area.

6 Finish

To put more power in the focal area (besides the note of intense Cobalt Blue you added in Step 4), mix a neutralized wash of Quinacridone Rose, New Gamboge and Cobalt Blue, but allow Quinacridone Rose to be slightly dominant. This combination will give the foreground and midground water shapes a warm, neutral middle value and make the focal area appear lighter. Paint this wash over all of the midground water shape as well as the large foreground area.

East on Big Bay, Moody
Watercolor on Arches Bright White 300-lb. (640gsm) rough paper
11" x 15" (28cm x 38cm)

Find Your Colors

To understand just how much your choice of colors affects a painting's mood, try painting the subject of the previous demonstration (page 32) again, but this time use a very different color scheme. Try the colors I picked here, or choose your own.

MATERIALS LIST

WATERCOLORS
Cadmium Yellow ❋ Cobalt Blue ❋ Cobalt Teal Blue ❋ New Gamboge ❋ Quinacridone Rose ❋ Winsor Red

PAPER
300-lb. (640gsm) rough, 11" x 15" (28cm x 38cm)

BRUSHES
½-inch (12mm) and 1½-inch (38mm) flat ❋ Nos. 4 and 8 round

OTHER MATERIALS
No. 2 pencil

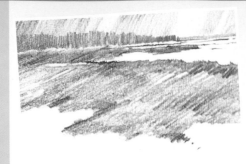

1 Value Study
This is the same value sketch used in the previous demonstration. In this drawing all the shapes are simplified, the focal area is well defined, and the value plan works. But this time, we'll create a different mood by changing the color scheme.

2 Draw Major Shapes and Do the Underpainting
Using a no. 2 pencil, draw all the shapes. Since you are going to use very strong color in this painting, you may want to press a little harder than usual so lines will remain visible through heavy applications of pigment.

Use your 1½-inch (38mm) flat to lay in a heavy wash of New Gamboge right through the focal area. While this wash is still wet, overlap it slightly with a strong mixture of Quinacridone Rose. While that's still wet, overlap it with a medium-value wash of Cobalt Blue. Make sure you overlap each stroke to blend all three colors well as they move out from the focal area. Allow this underpainting to dry completely.

3 Paint the Sky and Distant Headland

Mix stronger versions of the colors you used in Step 2. Use a 1½-inch (38mm) flat to wet the sky area, then carry washes of the stronger colors from the top edge down over both the distant headland and the large headland shape in the middle ground. This will ensure that the sky appears to be behind both headlands, not pasted in next to them. Allow your sky wash to dry completely.

Use a heavy mixture of Cobalt Blue and Cobalt Teal Blue to paint the distant headland shape. Remember, this is the time to push your use of color. Go overboard; use a more intense mixture than you think is necessary!

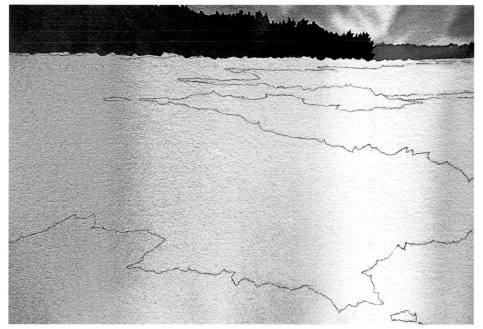

4 Paint the Midground Headland

On your palette, set out heavy, intense puddles of Quinacridone Rose, Cobalt Blue and New Gamboge, adding just enough water to put each color into solution. Let the puddles merge and blend.

Using a no. 4 round, paint the pine tree at the right end of the midground headland (the focal area) with an intense mixture of almost pure Quinacridone Rose. Work leftward, adding more Cobalt Blue to the mix as you go. Remember to go heavy with the paint; really push the limits of what you consider to be a wash. Allow all of this to dry.

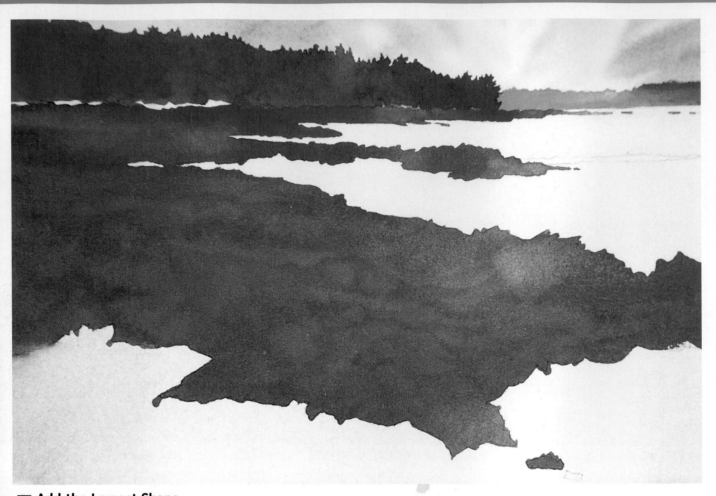

5 Add the Largest Shape

The shape next closest to you is the largest shape. It runs from right below the midground headland all the way to the foreground.

Mix some Cadmium Yellow with Winsor Red, letting the red dominate the mixture. Premix a large amount of pigment so you won't run out partway through. Start painting this strong, warm red into the tip of the headland right below the pine tree that defines your focal area. Keep this red strong and intense; you should have some extra punch near the focal area.

As you paint away from the focal area, add a little Cobalt Blue to the mixture. Leave unpainted slivers of space just beneath the headland to represent rocks. As you approach the foreground, add more and more Cobalt Blue. Allow all of this to dry completely.

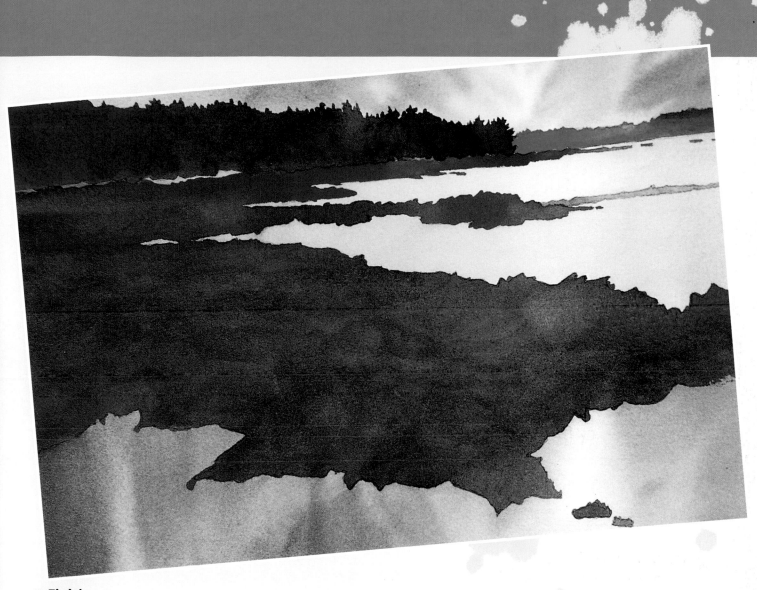

6 Finish

With a 1½-inch (38mm) flat, lightly brush plain water over the foreground water shape and most of the already painted land immediately above it. Your last wash should blend evenly from the foreground water shape over the land above.

Just as the shine starts to disappear, add a strong, medium-value wash of Quinacridone Rose and Cobalt Blue starting at the left edge of the foreground water shape. Paint your way toward the right, adding more Quinacridone Rose and New Gamboge as you go. By darkening the value of the foreground you place more emphasis on the lighter focal area.

Using a no. 4 round and a mixture of Quinacridone Rose, Cobalt Blue and a small amount of New Gamboge, carefully paint in the small island shapes and the unpainted spaces that were left in Step 5 for rocks along the bottom of the midground headland.

East on Big Bay, Your Colors
Transparent watercolor on 300-lb. (640gsm) rough paper
11" x 15" (28cm x 38cm)

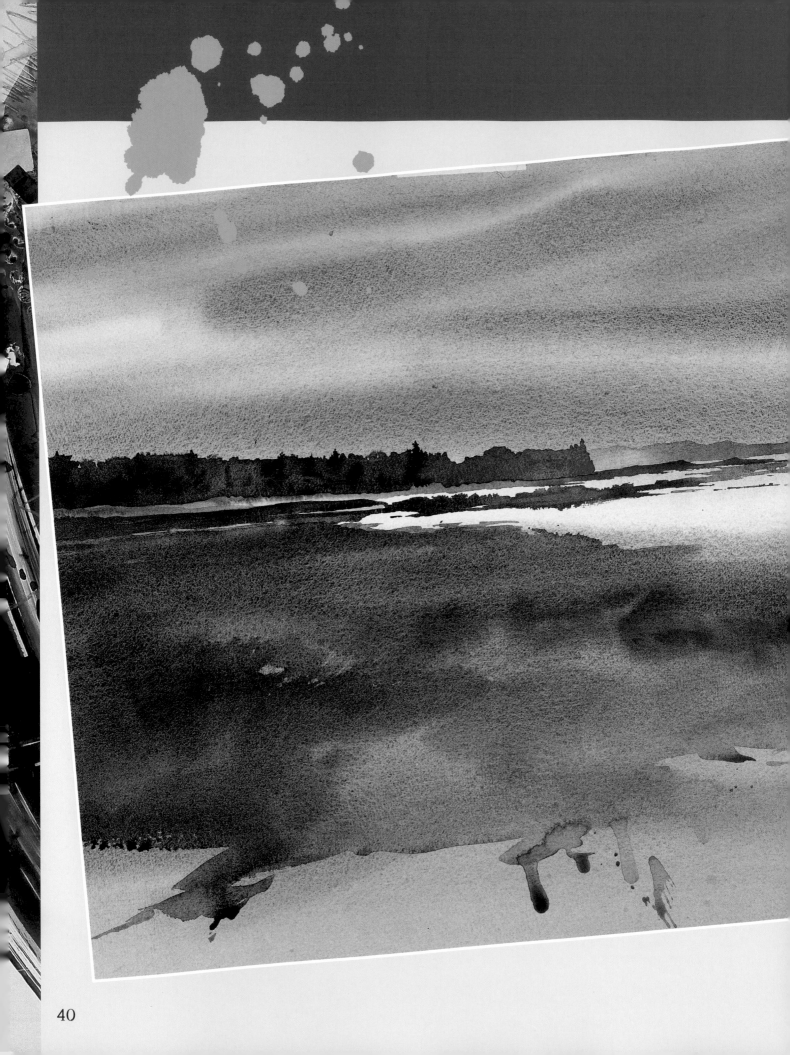

2 Tap Your Creativity

This chapter is full of projects and ideas to help you find fresh, creative approaches to your favorite subjects. You'll try combining photo references for a more effective painting, and you'll work on elevating an ordinary subject to something extraordinary. We'll talk about the importance of communicating emotions and ideas that are important to you. You'll be challenged to paint something you love that you may never have thought of painting before and to try an abstract painting based on a realistic subject.

But don't do the exercises in this chapter just one time; make them part of your painting routine. Carry a sketchbook and a small camera with you so you can capture the everyday subjects that mean something to you. Yet another run to the supermarket after work may spark a painting about the hectic pace of life. That pile of dirty laundry may offer wonderful textures just waiting to be interpreted. Always keep your eyes and mind open to painting possibilities.

East on Big Bay
Watercolor on 300-lb. (640gsm) Arches rough paper, Bright White
22" x 30" (56cm x 76cm)
Private collection

41

Vary Edges for Depth and Realism

How you paint the edges of shapes is important. Edges give visual clues about which shapes are closest in the picture space. Crisp edges look nearer; soft ones appear farther away. Edges also help tell the viewer what you, the artist, consider to be important in a painting.

You can't use edges to indicate closeness vs. distance or importance vs. subordinance if all the edges in your painting are the same. If you make all the edges hard, you'll end up with cookie-cutter shapes that look artificial. If you make all your edges soft, the viewer will have no idea what in the painting is most important to you.

Rather than limiting yourself to a few familiar brush techniques, try varying your edges using the examples on these two pages.

Lose an Edge
There are times when you should lose an edge, or part of an edge, entirely. While the shape is still wet, touch its edge with a brush loaded with plain water or with another color. (In this example I used a light value of yellow.) The wet color that is already on the paper will run into the new application of liquid, creating a lost edge.

The Wetter the Surface, the Softer the Edge
Both these examples are double strokes done on pre-wetted 300-lb. (640gsm) rough paper. To achieve the soft edges at left, I wetted the paper multiple times, then made the strokes with a loaded brush while the water was still shiny. For the example on the right, I followed the same steps except that I waited for the water on the surface of the paper to lose its shine before painting, which resulted in a sharper edge.

HARD AND SOFT EDGES CREATE DEPTH IN LANDSCAPES *In a landscape painting, a transition from hard to soft edges can help create a sense of atmospheric perspective. When you look around outdoors, notice the effect of distance on your ability to perceive edges. Close-up objects are sharp and crisp. As objects recede into the distance, their edges begin to blur or soften. At an extreme distance, shapes begin to merge and the edges are lost. You can create this same effect in your painting.*

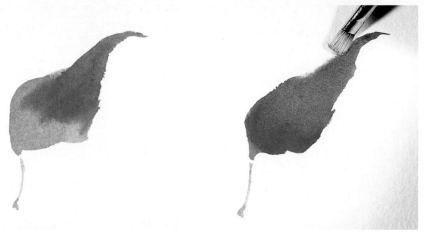
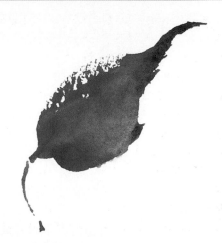

Use Hard Edges All Around or Soften an Edge

One way to paint a shape, such as this simplified leaf, is to make all the edges hard (left). Another way is to soften one edge (right). To soften an edge, moisten it, then gently scrub it with a stiff bristle brush. Blot up the loosened pigment with a tissue. Continue until you get the look that you want. Go slowly and evaluate each scrub so that you do not abrade the surface of your paper.

Make a Broken Edge

The upper left of this leaf shape has what is commonly called a broken edge. This is another way to add variety to your edges. This type of edge will not necessarily cause the shape to fade into the background. Rather, it is a textural edge and usually draws the viewer's attention.

Soften a Hard Edge With Close Values

The demonstration on pages 74–79, "Spray Watercolor With a Mouth Atomizer," relies on spraying paint through stencils. When you cut a shape out of a stencil, you make a hard-edged shape. How, then, does one create a soft edge in a stencil painting? Value control is the answer. An edge between two shapes of similar value is perceived as soft, even when it's technically hard.

Compare edges A and B in this illustration. The green and violet are very close to the same value, but there is high value contrast between the violet and the very light area to its right. Edge B appears harder than edge A because of the more dramatic value shift.

A B

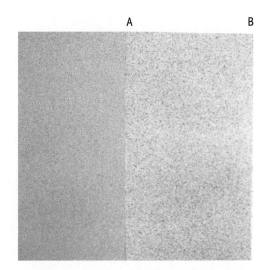

DEFINE THE FOCAL AREA WITH EDGES *The focal area is what you want viewers to see first; it makes sense to have hard, crisp edges there. As you move farther from the focal area, start to soften the edges. Let most of the edges farthest from the focal area be "lost," with just enough definition to be perceived without distracting from the focal area.*

Combine Reference Photos

A photograph is a wonderful memory jogger, but it can also be a crutch or a trap for the painter. The physical elements present in a reference photo might make for a poorly composed painting. Moreover, the high amount of detail a photograph contains might, in a painting, be better simply suggested or even omitted entirely.

In this demonstration, we'll use our critical and creative faculties to identify the best elements of several photos. Then we'll combine those elements to create one painting, leaving out elements that don't contribute to our visual statement.

MATERIALS LIST

WATERCOLORS
Cadmium Yellow ❋ Cobalt Blue ❋ Hooker's Green ❋ New Gamboge ❋ Phthalo Blue ❋ Quinacridone Rose

PAPER
300-lb. (640gsm) rough, 15" x 11" (38cm x 28cm) or 22" x 15" (56cm x 38cm)

BRUSHES
1-inch (25mm) flat ❋ Nos. 4, 6 and 10 round ❋ Inexpensive no. 4 round for masking fluid

OTHER MATERIALS
Nos. 2 and 5B pencils ❋ Masking fluid

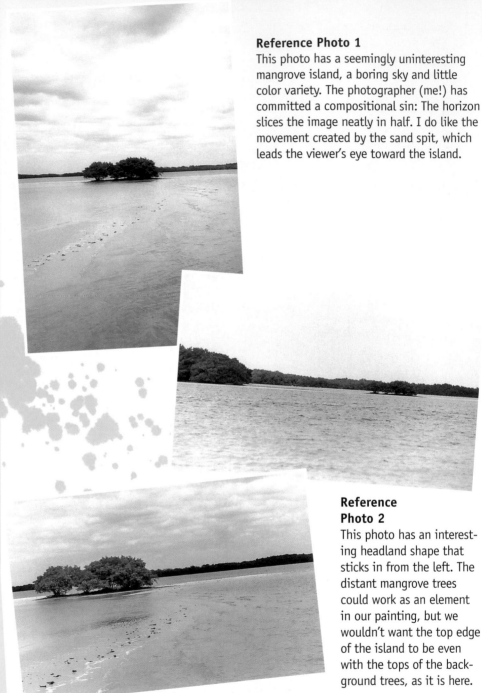

Reference Photo 1
This photo has a seemingly uninteresting mangrove island, a boring sky and little color variety. The photographer (me!) has committed a compositional sin: The horizon slices the image neatly in half. I do like the movement created by the sand spit, which leads the viewer's eye toward the island.

Reference Photo 2
This photo has an interesting headland shape that sticks in from the left. The distant mangrove trees could work as an element in our painting, but we wouldn't want the top edge of the island to be even with the tops of the background trees, as it is here.

Reference Photo 3
In this photo the sand spit is more prominent and makes a stronger gesture toward the island. The play of light is more apparent, too: There are shadows under the tree canopy, and the sand on either side of the island is brightly lit. But the horizontal composition works against the direction of the sand spit. Also, this photo lacks the interesting headland visible in reference photo 2.

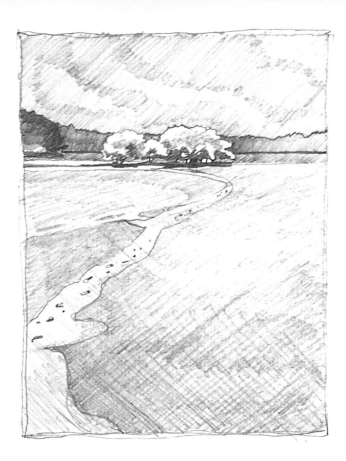

2 Draw and Mask

With a no. 2 pencil, draw the shapes on your paper. Using an inexpensive no. 4 round, paint masking fluid over the brightly lit areas: the sand spit near the island and the very tops of the mangroves.

3 Do a Wet-Into-Wet Underpainting

Apply clean water to the whole sheet with a 1-inch (25mm) flat. Wait for the shine to disappear, then brush on medium-value washes of Quinacridone Rose, New Gamboge and Cobalt Blue. Let this underpainting dry.

1 Value Sketch

With a no. 5B pencil, do a value sketch that brings together the desirable elements from the photographic references. I included the sand spit, the headland, the background trees, the island, and the deep shadows under the tree canopy in a vertical composition that echoes the forward movement of the sand spit. I dramatically raised the horizon line to break the picture into two unequal parts.

Assign values so that your greatest value contrast lies in and around the focal point, the island.

WHEN TO MASK *Usually it's easiest to paint around light shapes, but if many details need to be kept white or if surrounding washes need to flow uninterrupted through an area, masking fluid is the way to go. Just be sure the masking fluid is completely dry before you proceed to paint.*

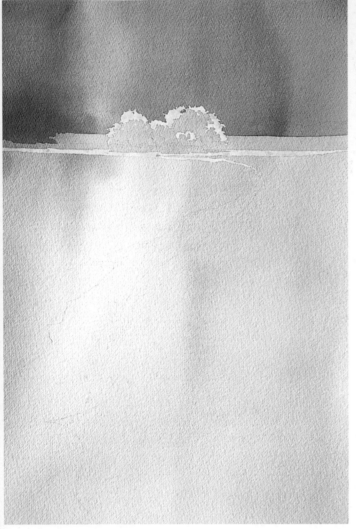

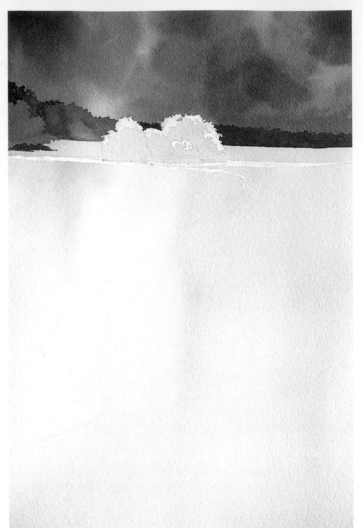

4 Paint the Sky Shape

The sky shape is farthest away—everything else is in front of the sky—so it makes sense to paint the sky shape first. Mix slightly darker washes of the same colors you used in Step 1. Re-wet the sky shape and wait for the shine to just disappear, then add the washes of Quinacridone Rose, New Gamboge and Cobalt Blue from left to right. Let the washes intermingle on the paper to create neutralized versions of the colors.

5 Enhance the Sky, Then Paint Forward in Space

For more drama and to better match the value plan, re-wet the whole sky, then just as the shine disappears, drop in stronger mixtures of Quinacridone Rose and Cobalt Blue with just enough New Gamboge to slightly neutralize them.

After the sky, the next closest shapes are the distant mangroves and the headland that juts in from the left and leads the eye to the focal area, the main island. Use a dark mixture of Quinacridone Rose and Cobalt Blue and a no. 6 round to paint these areas. Refer to your value plan; the distant mangroves should be quite a bit darker than the sky.

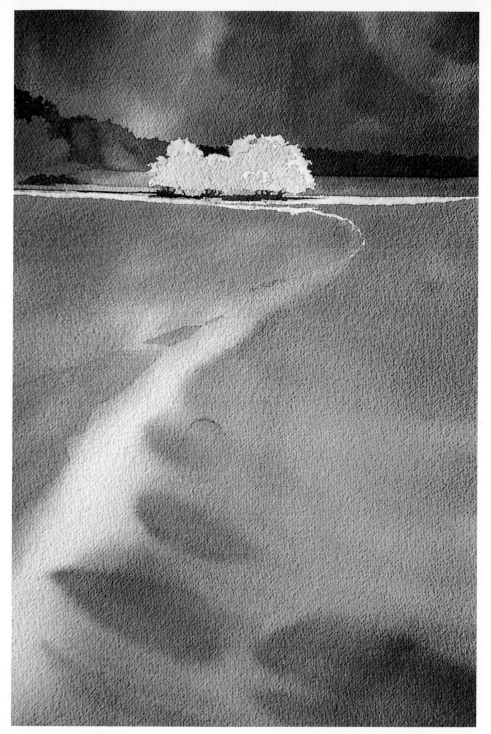

6 Add the Foreground Water

Use a 1-inch (25mm) flat to wet the entire foreground area. Run clear water right up to the edge of the distant mangrove background. Then, after allowing time for the shine to disappear, lay in a wash that is a medium-value mixture of Quinacridone Rose and Cobalt Blue. Let the warm Quinacridone Rose be dominant in your mixture around the island. As you move forward in space allow more of the Cobalt Blue to show. (While it is generally true that warm colors come forward and cool colors recede, it is not always necessary to keep warm colors in the foreground and cool colors in the background. In this case, you should use the warm colors to emphasize the island, your focal area.) While this large area is still wet, use a 1-inch (25mm) flat to lift out the sand spit that starts in the foreground and winds its way toward the focal point. Also lift out an indication of water moving across the sand. Remember that the main story is the sunlit island, not the foreground.

7 Remove the Masking Fluid, Then Finish

Use clean fingers or a commercial mask remover to carefully take off the masking fluid. Make sure you remove all of it.

Mix a dark violet from Quinacridone Rose and Phthalo Blue. With a no. 4 round, paint the dark shadows that fall beneath the island. Allow this to dry.

Using the same brush and mixtures of Hooker's Green, New Gamboge and Cadmium Yellow, model the foliage of the island itself. Remember that strong sunlight has a tendency to wash out color, so the closer you get to the top edge of the mangroves, the lighter the green should be. Leave a thin white edge at the very top to indicate to the viewer that the strongest light hits at that spot. The resulting value contrast will make your focal area really pop out at the viewer.

Sunlit Mangrove
Watercolor on 300-lb. (640gsm) Fabriano Artistico rough paper
15" x 11" (38cm x 28cm)

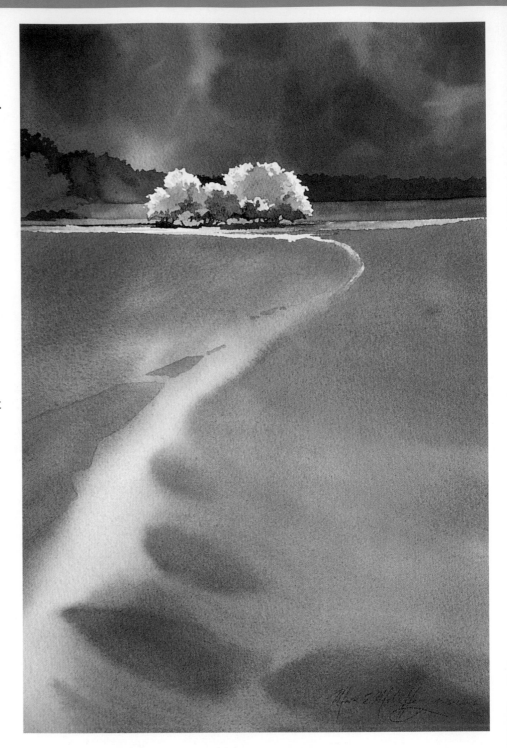

48

DEMONSTRATION
Elevate the Ordinary

One of your jobs as an artist is to interpret the world and your feelings about it. It is within your power to take something quite ordinary and, through your painting, show a viewer just how beautiful or meaningful it can be. Accordingly, let's try painting some very ordinary boxes.

MATERIALS LIST

WATERCOLORS
Alizarin Crimson �ળ Cadmium Yellow ✻ Cobalt Blue ✻ New Gamboge

PAPER
300-lb. (640gsm) rough, 22" x 30" (56cm x 76cm)

BRUSHES
1-inch (25mm) and 2-inch (51mm) flat ✻ Nos. 8 and 10 round

OTHER MATERIALS
Nos. 2 and 5B pencils ✻ Ruler

1 Value Sketch
Do a value sketch with a no. 5B pencil. Pay attention to the shadows cast by the boxes; the shadows will be shapes in the picture, too. You can vary the direction of the light source or even add a second light source to create interesting shadow shapes.

2 Sketch, Then Lay In First Washes
Draw the outlines of the boxes directly on the watercolor paper with a no. 2 pencil. (I used a ruler for this. There really is no better way to get straight lines; if you need a ruler, use it.)

Mix three light-value puddles of Cobalt Blue, Alizarin Crimson and New Gamboge on your palette. Using a 2-inch (51mm) flat, do a wash of clear water on the shadow areas only. Allow the shine to just disappear, then drop in washes of the three colors. Make the shadow slightly darker at the right point of the lower box; this will be the focal area. Allow all of this to dry thoroughly.

3 Add Darker Values

Make the puddles you mixed for Step 2 darker by adding pigment. Using a no. 10 round, paint the background wall and all the shadow areas with these stronger colors. Carefully avoid the box at center right. Don't forget to vary the color as you go across the page. Run Cobalt Blue and Alizarin Crimson together to create violet, then run that into areas of New Gamboge.

4 Paint the Lighter Shadows

The box on the right is in another box's shadow, but it will appear lighter than the shadow around it because of reflected light. Using a no. 8 round and the dark puddles you mixed for Step 3, paint the dark side of the right-hand box, then the side facing you, which receives the most reflected light. To vary the colors, use slightly more Cobalt Blue. Darken the lowest box, especially around its rightmost corner (the focal area). Paint the left side of the bottom box also. The left side will not be quite as dark as the right side because of reflected light.

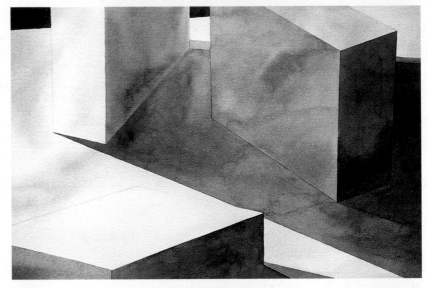

5 Paint the Tabletop

Mix a light-value wash of mostly Alizarin Crimson and a touch of New Gamboge. Use this wash and a 1-inch (25mm) flat to paint all of the table-top. Carefully avoid the top of the low-est box and the left edge of the left-hand box. These two surfaces receive almost direct light and will be the lightest shapes in the painting.

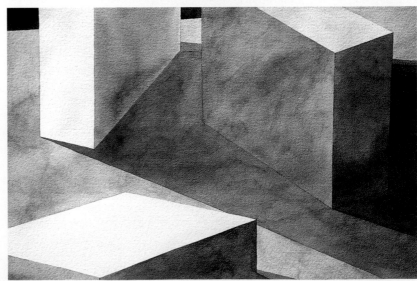

50

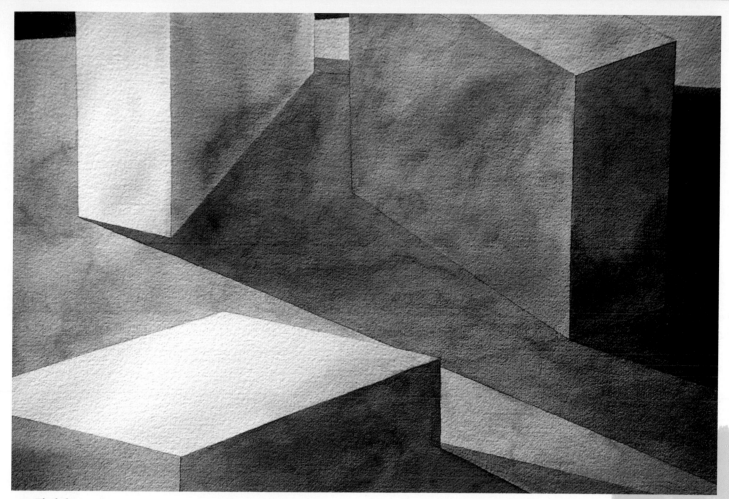

6 Finish

The two surfaces that receive direct light should stay very light in value in relation to everything else. Leave a bit of white paper along the leading edge of each of those surfaces to indicate that the light is strongest there. Then, working left to right, add to each shape a graded wash that starts with Cadmium Yellow, blends into New Gamboge, then blends into a warm orange made from New Gamboge and Alizarin Crimson.

Boxes in the Light
Watercolor on 300-lb. (640gsm) rough paper
22" x 30" (56cm x 76cm)

> **FOR LIVELY SHADOWS, USE A RANGE OF COLORS** *When you paint shadows, remember that light reflects back into shadow areas. For colorful and lively shadows, use several colors and don't be afraid to include lighter colors such as yellow.*

Subject vs. Content

Years ago, I had the revelation that an artist's job is not to just record information. I'm not sure what event sparked this, but it was part of a sincere effort to make better paintings.

Most of my beginning to intermediate students are still acquiring the manipulative skills necessary to describe the world as they see it—that is, to successfully represent a subject. It's a good idea to tune the hand and mind to work together; we could all use more drawing practice. But drawing skill alone does not make an artist.

What else do artists do?

Artists elicit emotion. They may do this by how they apply paint, by the colors they choose, by choosing unusual or shocking subject matter or by presenting ordinary subjects in a way that elevates those subjects to something extraordinary.

Artists communicate ideas. In fact, ideas are the reason many artists create in the first place. Some artists believe art should always be a social or psychological statement. Some use their art to try to influence opinion about a social issue. Still others use their paintings as a means of self-reflection and growth.

These emotions and ideas are the *content* of a painting. Portraying a subject is one thing; communicating the content of your painting is a whole different task.

Is it always evident to the viewer what content the artist wanted to convey? No, of course not—and that's not necessarily a bad thing. Understanding a painting in which the artist's intent is unclear is a challenge, and that challenge is often what draws a viewer to a work.

Learning to represent the world accurately is one part of being an artist, but the task of conveying content—your emotions and ideas—is no less important. Using the projects in this book, you can refresh your knowledge of design, color and value; learn new painting techniques; and practice applying principles such as contrast, unity, balance and emphasis. Study the principles and rules. Each time you paint, you can then decide whether you will follow those rules or ignore them—depending on which approach best supports the content you want to communicate.

Through these deliberate efforts, you will be more likely to create paintings that elicit a strong emotion or communicate an idea. This is a profound step in your creative development and is the beginning of becoming not just an observer but an artist.

I've chosen three paintings to show you, each of which succeeds at communicating content. Read the artists' comments on their own work, and think about how factors such as composition, color, value and texture support and convey the artists' ideas.

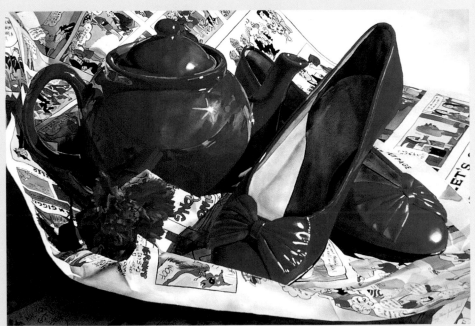

A Single Color Stands for Much More

Fun, upbeat, reflective, bright and detail oriented . . . those terms describe both Peggy Flora Zalucha and her paintings.

Peggy says: "Hopefully, people who view this painting will come away knowing more about me. In my paintings, a red carnation always represents me. Here the carnation is surrounded by elements of my life: fun stuff, bright stuff, shoes I wear to openings, and so on."

Red Means
Peggy Flora Zalucha

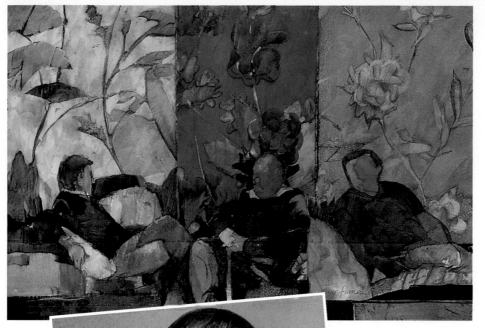

Large-Scale Textures Suggest a Deeper Meaning

I smile every time I see one of George James's marvelous paintings. He is creative, immensely talented and a heck of a nice guy.

This painting on Yupo shows three figures that represent George, his brother and their dad.

George says: "This painting represents our family after my mother passed away. The floral patterns create a visual foil to reinforce the figures. Looking back on my childhood, I remember wallpaper everywhere; I seem to touch on that wallpaper thing a lot in paintings made from memories. The painting deals with family, hopefully in an upbeat way."

The James Boys

George James, AWS/NWS
Watermedia on Yupo
26" x 40" (66cm x 102cm)

Multiple Symbolic Elements Tell the Story

Barb Hranilovitch is a wonderful commercial and fine artist and a master of gouache. The subject of this small painting is a woman in a dark dress, but oh, what symbolism!

Barb says: "This painting is about my mother, our relationship and my attempt to understand her. The oak leaves are black and white because that is how I've felt my mother often sees the world. The glasses are about her perception. The barbed wire, as it changes into a rose, is about forgiveness. The woman's stance is reminiscent of old religious art. I feel motherhood is often given a holy status, when in fact mothers are just people doing the best they can."

Thou Shalt

Barb Hranilovitch
Gouache on Arches 140-lb. (300gsm) hot-pressed paper

Paint What You Know

Many painting instructors advise students to "paint what you know." It's sound advice: If you paint things that have great meaning for you, your heart and passion will show and you'll make better paintings.

The painting in this demonstration is of something that has great personal meaning to me. I have been a serious fisherman since I was five years old. I own a boat; I make my own fishing rods and tie my own flies; and, with my wife, Rosie, I have traveled all over the world on fishing trips.

The fish in this painting are tarpon in shallow water. Tarpon are warm-water fish that can reach 50 pounds (23kg), or sometimes much more. When hooked, tarpon may jump 10 feet (3m) clear of the water. They can run without stopping for hundreds of yards. To hook one is truly an experience; to land them can become an obsession.

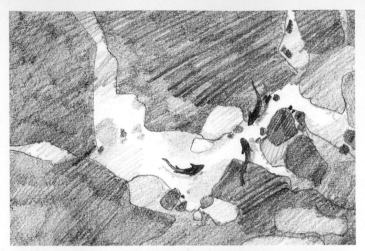

MATERIALS LIST

WATERCOLORS
Alizarin Crimson ✽ Phthalo Blue ✽ Ultramarine Blue

PAPER
140-lb. (300gsm) cold-pressed, 14" x 21" (36cm x 53cm)

BRUSHES
1-inch (25mm) and 1½-inch (38mm) flat ✽ Nos. 4 and 6 round

OTHER MATERIALS
No. 5B pencil ✽ Toothbrush for spattering

1 Value Sketch
I used some artistic license as I planned this painting. A bird's-eye view from a boat in shallow water would be unlikely, as tarpon are easily spooked. I also made the fish darker than they really are.

2 Underpainting
Use a 1½-inch (38mm) flat to wet the sheet. Wait for the shine to just disappear. Using various mixtures of Ultramarine Blue and Alizarin Crimson, lay in rock shapes. Leave some white areas to help the viewer's eye weave through the composition.

NEGATIVE PAINTING *Negative painting—defining an object by painting the space around it—is a very important tool, especially for artists working in transparent watercolor. We can't paint light values on top of dark ones; instead we must paint around light shapes to "reveal" them. Here's a work that uses negative painting to the fullest, creating depth and light in a street scene of marvelous complexity.*

Pigeon's Roost
Frederick Graff:
Watercolor: 30" x 22"
(76cm x 56cm)

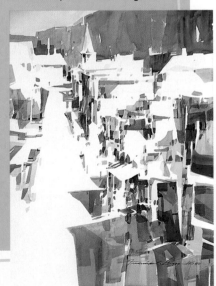

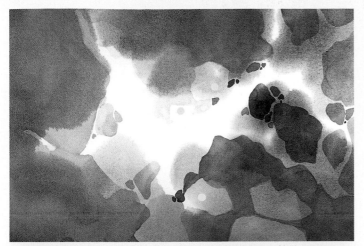

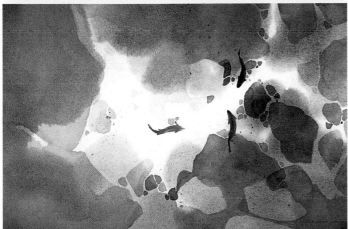

3 Define the Rocks

Using a 1-inch (25mm) flat and mixtures of Ultramarine Blue and Alizarin Crimson, paint more rock shapes. In and around the focal area, place smaller, more-intense shapes and use a stronger mixture heavy on the Alizarin Crimson for some of the shapes. This will communicate to the viewer that something important is happening here.

To create rocks with a variety of values, use negative painting to reveal light-value rocks against a darker background.

4 Paint the Fish

To paint the fish, use the double-dip technique (illustrated below), loading a no. 6 round first with Phthalo Blue, then dipping just the tip into a thick mixture of Alizarin Crimson. Vary the amount of Alizarin Crimson for each fish. Try to keep the fish shapes dark enough that the rocks do not show through the fish. Use a no. 4 round to add tails and fins. Allow the fish shapes to dry completely.

Double-Dip Technique

1 Double-Dip the Brush

Dip a round brush into the first color, then dip just the tip into a strong, thick mixture of the second color. I dipped into the darker color first, then the lighter color. The darker color will dominate.

2 Make the Stroke

As you lower your brush onto the paper, begin to pull it for the stroke. This will allow both colors to retain their identity.

3 Result

The result is one stroke, yet two colors. Try turning your brush sideways or even triple-loading it; experimentation is a great way to learn.

5 Add Shadows

Use a no. 6 round and a violet mixture of Ultramarine Blue and Alizarin Crimson to paint the shadows for each fish. The closer a fish is to the ocean bottom, the more distinct its shadow will be. Don't forget to add shadows for each fin. Accurate shadows will convince the viewer that your fish are suspended in their watery world.

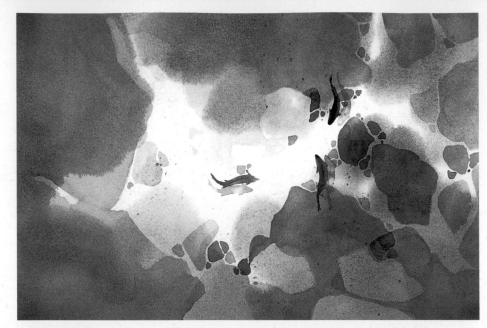

6 Finish

To give the impression of a rubble-strewn ocean bottom, add a textural spatter. Dip an old toothbrush into a mixture of Alizarin Crimson and Ultramarine Blue. Do a test spatter on a separate piece of paper until you achieve the pattern you want, then spatter your painting.

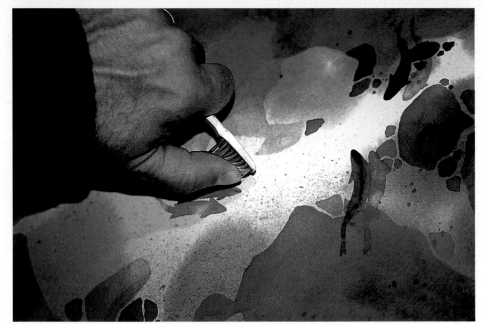

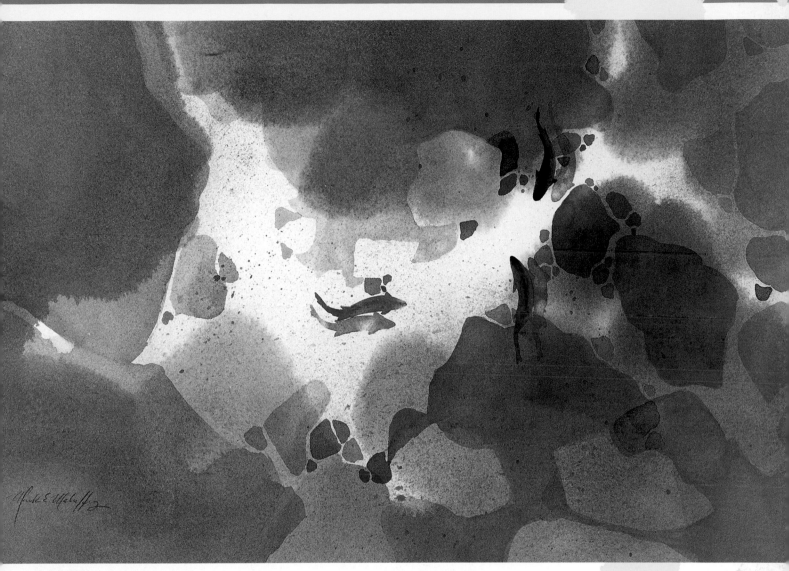

Cool Fish
Watercolor on 140-lb. (300gsm) cold-pressed paper
14" x 21" (36cm x 53cm)

Do an Abstraction of a Realistic Subject

An abstraction is a construction based on realistic subject matter. Sometimes the original subject becomes so distorted that it is hard to tell what that subject was. Unless the artist happens to be present to explain the work, the viewer gets to interpret it. Does the viewer sometimes come up with a completely different interpretation than the one the artist intended? Of course, but that's part of the fun of abstract art!

Let's try a painting loosely based on an aerial view of a bridge across a large river.

MATERIALS LIST

WATERCOLORS
Alizarin Crimson ✻ Cadmium Yellow ✻ Cobalt Blue ✻ Hooker's Green ✻ New Gamboge ✻ Phthalo Blue ✻ Quinacridone Rose ✻ Ultramarine Blue ✻ Winsor Red

PAPER
300-lb. (640gsm) rough, 15" x 11" (38cm x 28cm)

BRUSHES
¹/₂-inch (12mm), 1-inch (25mm) and 2-inch (51mm) flat ✻ Nos. 4 and 8 round ✻ Inexpensive no. 4 round for masking fluid ✻ Oil bristle brush for scrubbing ✻ No. 4 or 6 rigger

OTHER MATERIALS
Nos. 2 and 5B pencils ✻ Masking fluid ✻ Yupo for stencil ✻ Craft knife ✻ Paper towels

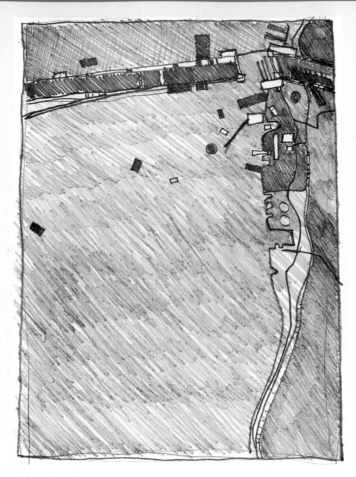

1 Value Plan
Do a value plan in your sketchbook. As you design the shapes of the drawbridge crossing the river, remember that a cross is unavoidably a focal point. Concentrate the smallest shapes and the highest contrast here. Use a no. 5B pencil to indicate the bridge, shoreline, railroad, buildings, barges and circular storage bins.

2 Draw and Protect
Using a no. 2 pencil and guided by your value sketch, draw every shape onto your watercolor paper. Use an inexpensive no. 4 round to cover shapes with masking fluid as shown here. Let this dry completely.

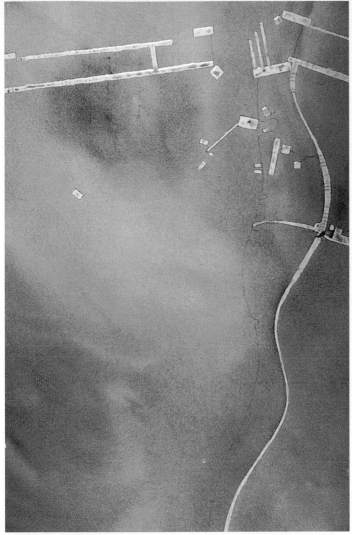

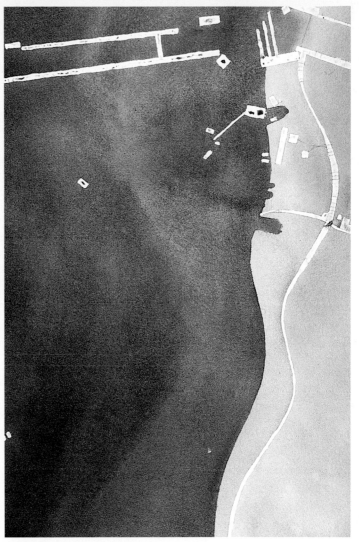

3 Do the Underpainting

Use a 2-inch (51mm) flat to wet the entire paper surface. Allow the shine to disappear. Brush medium-value mixtures of Ultramarine Blue, Quinacridone Rose, Alizarin Crimson and New Gamboge over the entire painting. The focal area will be the juncture of the shoreline and the bridge, so let the Alizarin Crimson and New Gamboge dominate the mixture in this area. You should use a slightly more intense color there.

4 Paint the Shoreline

Use a 2-inch (51mm) flat to apply clear water to the entire river shape. Let the shine disappear, then lay in heavy mixtures of Ultramarine Blue, Quinacridone Rose and New Gamboge. Keep the mixture a little more intense around the focal area. Allow these colors to mix right on the paper to form warm and cool neutrals and neutralized colors. Let everything dry thoroughly.

> **ABSTRACT DOESN'T MEAN UNPLANNED** *Some artists new to abstraction think that because a painting will be abstract they need not sketch or plan it. But it's just as important in abstraction as in representational painting to place shapes, assign values and locate the focal point. Unplanned paintings almost always end up looking weak in composition and execution.*

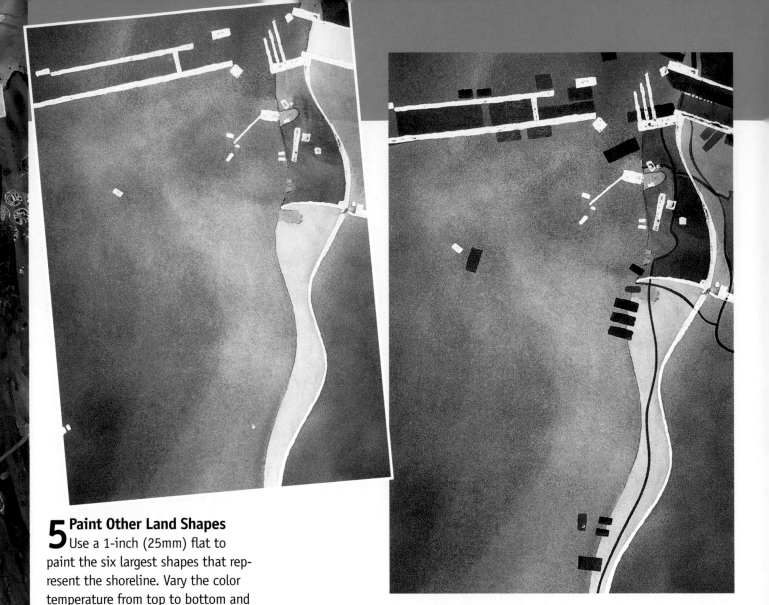

5 Paint Other Land Shapes

Use a 1-inch (25mm) flat to paint the six largest shapes that represent the shoreline. Vary the color temperature from top to bottom and within each shape. Use Ultramarine Blue, Quinacridone Rose, Alizarin Crimson, New Gamboge and Cobalt Blue. Think variety!

6 Add the Darks

Using very strong mixtures of Ultramarine Blue, Phthalo Blue and Quinacridone Rose and a ¹/₂-inch (12mm) flat, add the darks. Use squares and rectangles to represent the bridge roadway, the bridge support, the docks and the barges. Placement of these rectangles is key; remember where the focal area is and place the smallest shapes there. Use a no. 4 or 6 rigger to paint the lines, which represent the service road that follows the shoreline and weaves in and out of the docks.

Lifting Out Shapes (Step 7)

1 Scrub Out Paint

Use a craft knife to cut a circle out of a piece of Yupo. Use clear water and an stiff oil bristle brush through the stencil to gently rub and loosen a circle of paint. (If the brush is not stiff enough, use a sharp craft knife to cut the bristles down; it will be much stiffer.)

2 Lift the Shapes

As soon as the paint is wet and loosened, quickly lift it away with a paper towel.

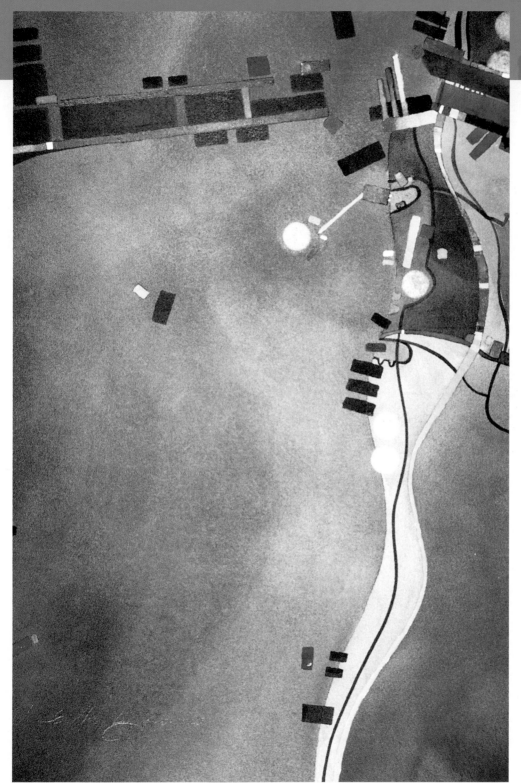

7 Add Representative Shapes

Use clean fingers or mask remover to remove all the masking fluid. Use a no. 4 round to carefully paint most of the revealed shapes; they represent the bridge, the storage bins, the cement bridge supports, the buildings, the barges and the railroad that follows the shoreline. Use strong, intense mixtures of Ultramarine Blue, Phthalo Blue, Hooker's Green, Winsor Red, Alizarin Crimson and Cadmium Yellow. Use gradation of both value and temperature within some shapes to add interest.

After evaluating the painting you may wish to add a few round shapes to suggest oil or grain bins. These shapes will contrast with the straight edges and rectangles. Lift out the circles as shown on the facing page.

River, View From Above

Watercolor on 300-lb. (640gsm) rough paper
15" x 11" (38cm x 28cm)

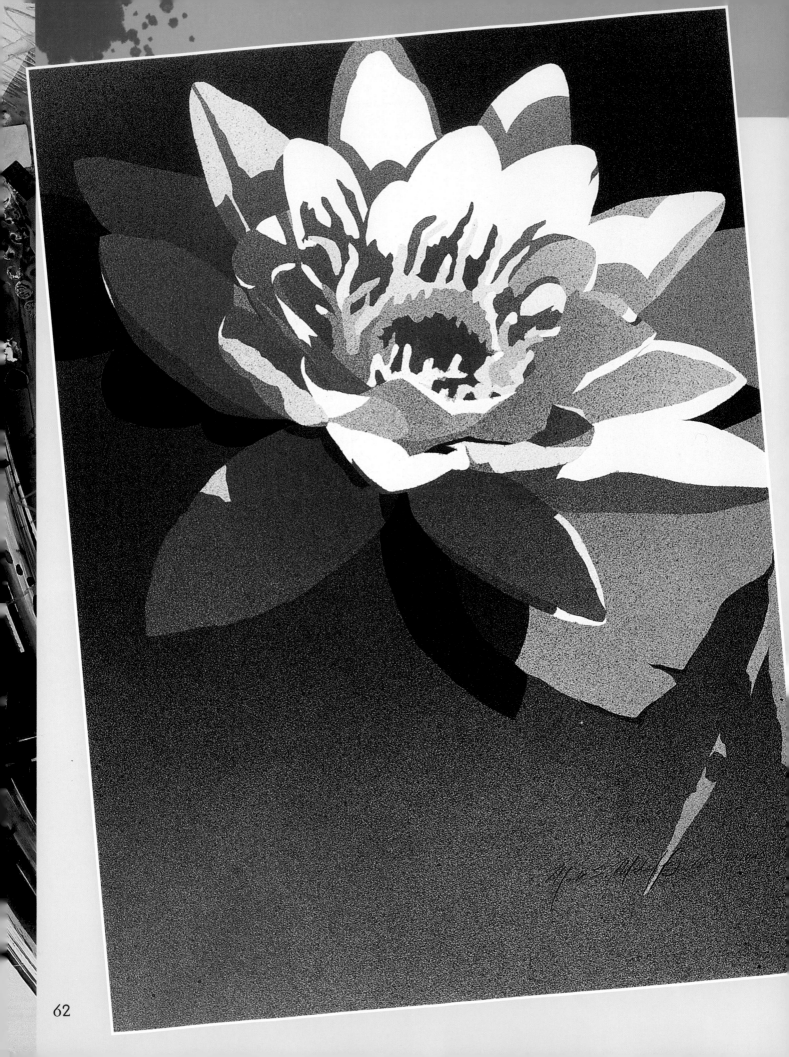

3 Apply Watercolor in New Ways and Add Other Mediums

Transparent watercolor is versatile. It can be used in very thin washes or glazes, it can be runny and juicy, or it can be used thick right from the tube. Watercolor also lends itself to patterning and texturing. In this chapter we'll try some creative new ways of applying watercolor.

Watercolor can also be used with or on top of many other mediums. It works well with pencil, charcoal, ink, acrylics, casein, gouache, colored pencil (both wax based and water soluble) and pastel. Why combine mediums? It's a new challenge, and it can help you tell your visual story. For example, a watercolor of a thunderstorm might benefit from an intense acrylic underpainting.

You never know where your next painting idea will come from. A new method of applying paint or combining mediums might be just the spark you need.

Morning Light 2
Sprayed watercolor on 140-lb. (300gsm) hot-pressed paper
29" x 20" (74cm x 51cm)

Roll On the Watercolor

Try using a foam paint roller to apply texture. This technique can be used as a painting start, for an isolated section of a painting, or to work an entire painting from start to finish.

1 Roll on the First Color

Squeeze out a generous amount of Peacock Blue straight from the tube onto your palette and roll over it. Leave gaps in the coverage of the roller so that when you roll it out on paper there will also be gaps in the amount of paper covered. This will create a more irregular, textured look.

2 Add a Color

Squeeze a bead of another color (Quinacridone Rose) onto your palette. Roll this out and add the resulting texture to the previously applied paint. Where the two colors overlap, they will form violet; where you left gaps of coverage in Step 1, the cool red will show alone.

3 Add Another Color—The More the Merrier

Add a third color (in this case, the final primary New Gamboge). Roll this over the other colors. As you do this, you'll notice the secondary colors being formed where the primary colors overlap.

The Finish
Here are all the layers of texture applied with the foam roller. They are interesting and could end up as part of your next painting!

64

Drop Paint Onto a Wet Surface

Dropping paint onto wet paper can form beautiful shapes that have soft edges yet still retain the shape you intended. To achieve that, you must wait until the time is right to apply paint, then be ready to work quickly.

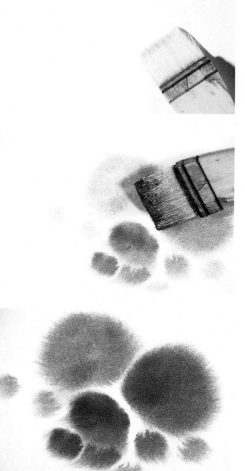

1 Do a Water Wash
Using a 2-inch (51mm) soft wash brush, cover your paper with clear water. Go over it a couple of times to make sure that you have not left any gaps in coverage.

2 Drop In Paint
Watch the paper surface. Wait for the water's shine to just disappear, then load your brush and drop in some paint. (It's important to wait until the shine disappears but no longer. If you time it right, you'll end up with soft-edged shapes that retain their integrity.)

3 Add More Shapes
You can continue adding new shapes, but work quickly, because the paper is continually drying. In this case I dropped in circular shapes that could be underwater rocks, the centers of flowers, or storm clouds—almost anything!

WAIT FOR THE SHINE TO DISAPPEAR *If you drop paint onto wet paper before the shine has disappeared, the shapes won't retain the edges you intended; paint will run and bleed all over.*

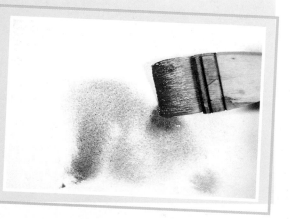

Use Thick Paint Right From the Tube

For intense, saturated color, try using undiluted watercolor straight from the tube. The rich colors you get will knock your socks off!

1 Squeeze Paint Straight From the Tube

Squeeze some fresh paint onto your palette. (You won't get juicy, thick color by reconstituting the dried paint that usually sits in your palette—it can't be done.)

2 Move That Pigment

Use an oil bristle brush to pick up a large amount of paint. (This kind of brush is stiff enough and has enough spring to push around a heavy load of thick paint.) Apply the paint as is, or add just enough water to get it to behave.

3 Blend As You Go

Use a bristle brush to blend or gradate color within a shape. Watercolor applied straight from the tube will remain blendable longer, which can yield very smooth transitions in value or color. It's almost like painting with acrylic, but watercolor moves and blends much easier.

FRESH PAINT MEANS RICH COLOR *Make it a rule to always squeeze out fresh paint before you begin a painting session. (You might make an exception if you're planning to do a high-key painting, one that leans toward the light end of the value scale with no darks.)*

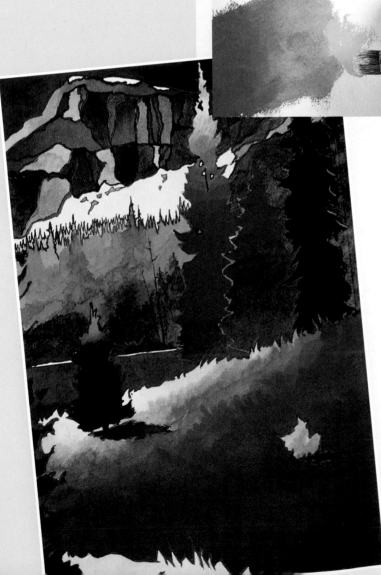

Look at the eye-popping color you can get by using watercolors straight from the tube!

Mountain Light
Watercolor on 300-lb. (640gsm) Arches rough paper, Bright White
22" x 15" (56cm x 38cm)

Alcohol and Salt

Alcohol Spritz

Rubbing alcohol (isopropyl alcohol) quickly repels wet watercolor and creates a very interesting pattern. Spritzing water will also produce a pattern, but the pattern you can create with alcohol is much stronger.

Salt

Salt, arguably the most overused texturing substance, is too often used to try to lend interest to a painting that should be redesigned. Use salt texturing (or any other texturing technique) to support the idea of your painting rather than for its own sake.

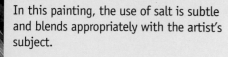

In this painting, the use of salt is subtle and blends appropriately with the artist's subject.

Bella Burano
Judy Morris, AWS
Watercolor on Arches 300-lb. (640gsm)
cold-pressed paper
29" x 22" (74cm x 56cm)

Alcohol

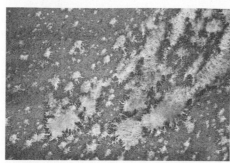

This is the result of spritzing alcohol into a wet wash on hot-pressed paper. Hot-pressed paper, being smooth, does a good job of showing the pattern created as the alcohol pushes the paint aside. In general, texturing techniques done with wet paint will show up better on smooth paper.

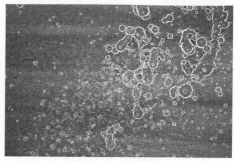

Here is a spritz of alcohol executed on Yupo, which has a very smooth finish. Any texturing done on this surface will really show!

Salt

1 Make It Wet
Using a wide brush, apply a very wet wash of color to a piece of hot-pressed paper.

2 Time It Right
Watch the surface of your paper closely. Just as the shine starts to disappear is the right moment to drop, shake or throw salt into the wet wash.

3 Let Dry, then Remove the Salt
Allow the wash to dry completely; this will take quite a while. Then knock off or gently rub off the salt.

MINI DEMONSTRATION
Plastic Wrap and Bubble Wrap

Bubble Wrap® and plastic wrap leave a textured impression when laid into wet paint. Plastic wrap can be crumpled to form interesting patterns. Bubble Wrap can be cut or torn to the desired size and shape. The process is essentially the same for both materials: Lay the material into a wet wash, let the wash dry completely, then remove the plastic material. The resulting texture may remind you of rocks, bark or water... whatever your imagination tells you!

Bubble Wrap

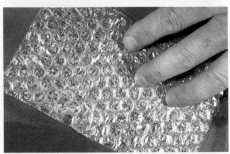

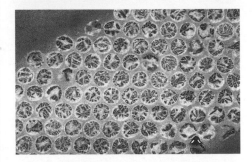

1 Keep It Wet
Use a 1-inch (25mm) flat to apply a wet wash to cold-pressed watercolor paper.

2 Press It In
Immediately lay a piece of Bubble Wrap into the wet paint. Press firmly to make sure all the bubbles get pushed into the wet paint. Do not remove it yet; allow the paint to dry completely. If you pull the Bubble Wrap off before the trapped paint can dry, the resulting texture will not be as evident.

3 Remove
Remove the Bubble Wrap. If you waited until everything is completely dry, the resulting texture will show the bubble pattern.

Plastic Wrap

Plastic Wrap on Cold-Pressed Paper
A plastic wrap texture on cold-pressed paper, while visible, is not as "textured" as it would be on hot-pressed paper.

Plastic Wrap on Hot-Pressed Paper
Hot-pressed paper is smoother than cold-pressed, so the plastic wrap leaves harder edges.

Plastic Wrap on Yupo
The plastic surface of Yupo is even smoother than that of hot-pressed paper, and the resulting texture is very strong.

Other Texture Ideas

Textured Drop-Ins

Try dropping anything with a textured surface into wet paint: rolled insulation; non-skid rubber mat; heavily textured cloth; or one of my current favorites, textured mat board. You may find a texture you like so much that you return to it over and over.

Scratching

Scratching wet paint has been done by many painters. Try it for yourself, then decide if it will work for you.

Textured Mat Board
Lay textured mat board on wet paint, allow the paint to dry, then remove the board.

Scratching

1 Apply a Wet Wash
Quickly lay in a very wet wash using a 1½-inch (38mm) flat.

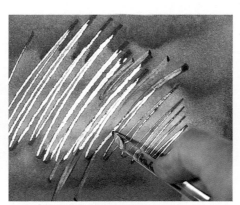

2 Use Some Muscle
Use the chiseled end of a brush handle to scrape the wet wash. Press hard to scrape the paint aside and reveal the white of the paper.

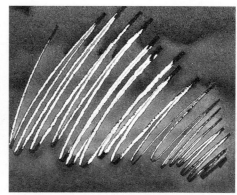

3 Interpret the Result
A scraped texture could suggest tree bark, tire tracks, flower stems, lightning. . . . Use your imagination and scrape away!

Use Texture Appropriately for Impact

In most instances I think it's better to err on the side of understatement when using texture. Texture alone does not make a great painting; beware of letting it become an end in itself. Used well, texture can enliven a surface, represent something real or even elicit an emotion.

Flicked Paint Creates a Forest
In this painting, I applied the thick forest by loading a brush with paint, then flicking the paint onto the surface from top to bottom. I did this over and over to build up many layers. I added directly with a brush just enough side branches to communicate the idea of a thick forest. The painting is really about texture; I added the deer to give scale and further reinforce that the painting is to be read as a forest.

Deer Woods
Watercolor on gessoed 300-lb. (640gsm) cold-pressed paper
22" x 30" (56cm x 76cm)

Poured Color Echoes the Movement of Water
This work has numerous pours of Ultramarine Blue and Quinacridone Rose from the upper left toward the lower right. If you want each layer or pour to show, be sure to allow plenty of drying time between pours. These layers provide the viewer with visual clues that say "ocean wave."

Ocean Mandala
Watercolor on 140-lb. (300gsm) cold-pressed paper
33" x 42" (84cm x 107cm)

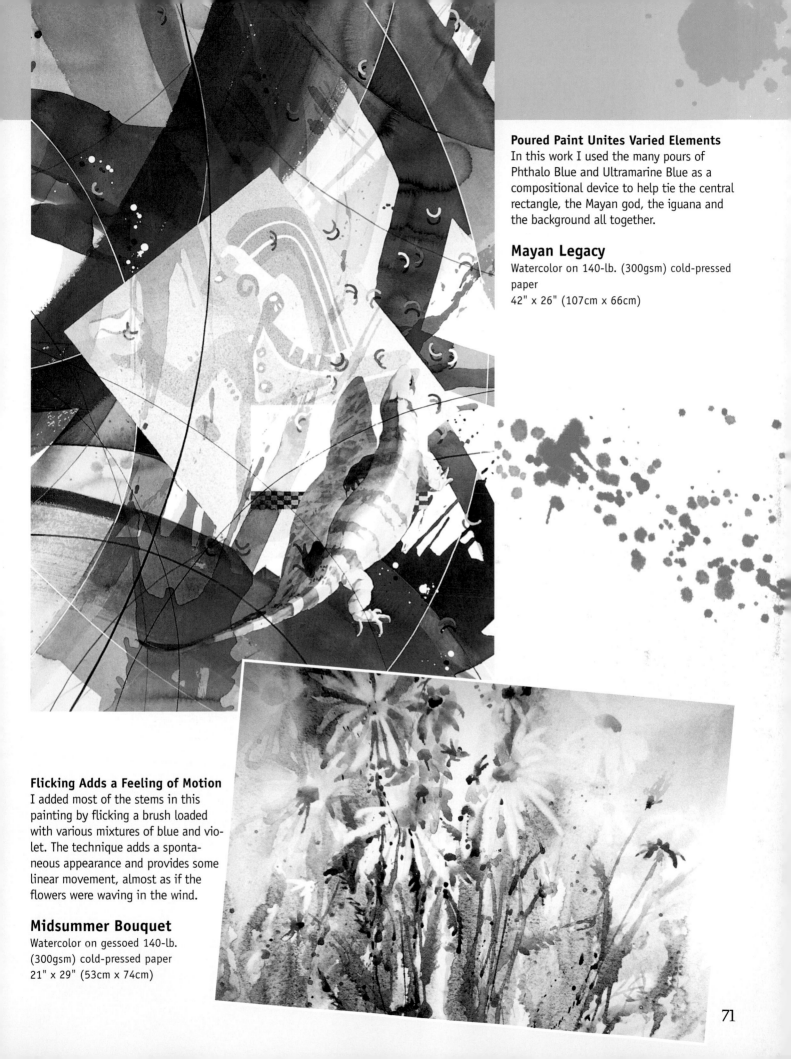

Poured Paint Unites Varied Elements
In this work I used the many pours of Phthalo Blue and Ultramarine Blue as a compositional device to help tie the central rectangle, the Mayan god, the iguana and the background all together.

Mayan Legacy
Watercolor on 140-lb. (300gsm) cold-pressed paper
42" x 26" (107cm x 66cm)

Flicking Adds a Feeling of Motion
I added most of the stems in this painting by flicking a brush loaded with various mixtures of blue and violet. The technique adds a spontaneous appearance and provides some linear movement, almost as if the flowers were waving in the wind.

Midsummer Bouquet
Watercolor on gessoed 140-lb. (300gsm) cold-pressed paper
21" x 29" (53cm x 74cm)

Throw Found Objects Into Wet Paint

Anything dropped or thrown into wet paint and allowed to dry there will leave its mark in the paint. It is a simple form of printing. Try these examples, and come up with your own ideas. Sand, pebbles, leaves—practically anything will work.

For dramatic results, select a very smooth paper like Yupo plastic paper. Of any of the common watercolor surfaces, Yupo will show the greatest detail. Experiment with hot-pressed, cold-pressed and rough surfaces as well.

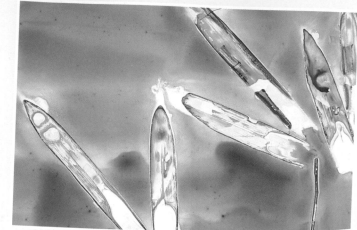

Bamboo on Yupo

Bamboo on Hot-Pressed Paper

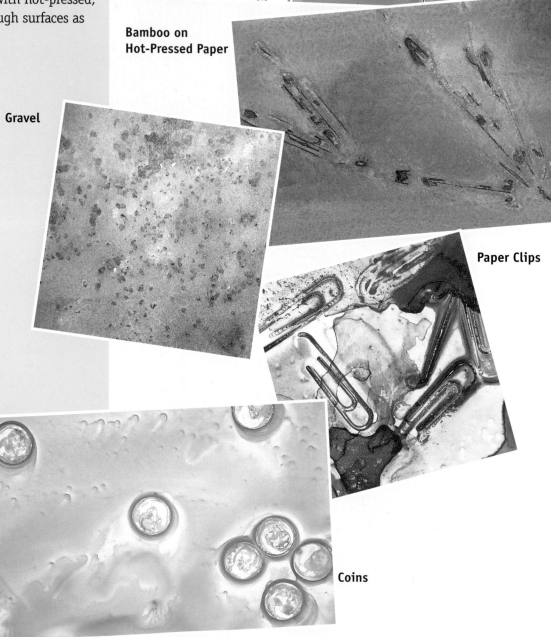

Gravel

Paper Clips

Coins

72

Three Ways to Throw Paint

Throwing paint can be the height of spontaneous application. I admit there have been times when a painting was not going well and I threw paint at it in frustration! However, you may wish to try these three methods for a little more control.

Pour

Fill any container with liquid paint and pour the contents across your painting surface. You can control the amount you pour and the general direction, but that's about it. Pouring can add a random, almost natural feel to your image.

Flick

For this method, load a brush heavily and throw that paint across the paper with an abrupt flick of the wrist. The resulting pattern will be elongated in the direction of your wrist movement.

Tap

Load a brush with pigment and then tap the brush against the handle of another brush over your painting surface. With this method you have control over the shape of the patterned area.

Poured and flicked paint

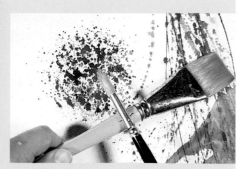

Tap, Tap, Tap

A circle of tapped paint

Spray Watercolor With a Mouth Atomizer

This project uses a mouth atomizer, an inexpensive tool for spraying paint. See page 15 to learn the science behind how it works.

A mouth atomizer gives a consistent texture of dots that can add an interesting element to an already sound arrangement of shapes and values. An atomizer can also be used to spray around a dropped object or a masked shape, leaving a silhouette. You can even spray opaque mediums such as acrylic, ink and gouache.

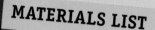

MATERIALS LIST

WATERCOLORS
Alizarin Crimson ✖ Cadmium Yellow
✖ Opera ✖ Peacock Blue ✖
Phthalo Blue

PAPER
140-lb. (300gsm) hot-pressed,
stretched, 21" x 29" (53cm x 74cm)
✖ Tracing paper, 21" x 29" (53cm x
74cm)

BRUSHES
No. 2 round

OTHER MATERIALS
No. 5B pencil ✖ Masking tape ✖
No. 11 craft knife and at least 10
extra blades ✖ Frisket film ✖
Spoon or credit card for burnishing
✖ Mouth atomizer ✖ Baby-food
jars or any sealable jars

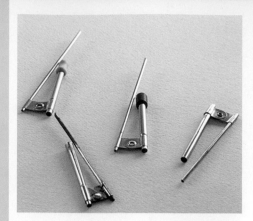

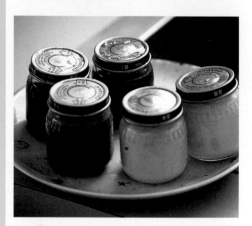

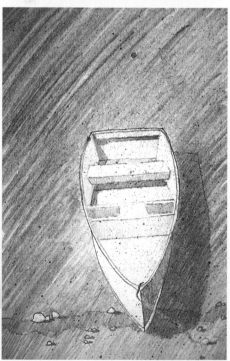

Mouth Atomizers

I like to keep several mouth atomizers around because each one performs a little differently. Some work without much force; with others, you have to blow very hard. Some throw big dots of paint; others create various-sized dots. Generally, the harder you blow the smaller the dots.

1 Put Tube Watercolors In Solution

Prepare a jar of dissolved paint for each color in the Materials List as follows: Squeeze a glob of paint 1" (3cm) wide into a baby-food jar. Fill the jar with water, leaving a little space at the top; put the lid back on and tighten securely. Shake the jar vigorously until your arm is sore, then switch arms and shake some more. Keep shaking until there is no more paint stuck to the bottom of the jar.

2 Value Plan

In your sketchbook, draw a value plan that assigns to each shape a value: white, light, medium or dark. You will be cutting every shape out of the frisket film, so plan your overall design now, and make your shapes exact.

4 Prepare the Watercolor Paper
Put a border of masking tape around the edge of the stretched watercolor paper. (The frisket film will stick to the masking tape and stay in place as you spray.) Tape the paper securely to a flat surface so the paper will stay put as you peel film off it.

5 Peel the Frisket Film
Cut a piece of frisket film a couple of inches larger than your watercolor paper. Remove the paper backing from the film. (You may need a helper when handling the sticky film.)

6 Place the Film on the Sketch
Lay the film sticky side down onto the working drawing. Smooth out bubbles and wrinkles from the center to the edges. Use a large spoon or the edge of a credit card to burnish the lines and help pick up the graphite.

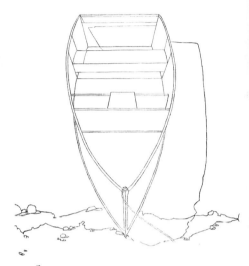

7 Transfer the Sketch
Now peel the film off the tracing paper and lay the film sticky side down onto the watercolor paper. Smooth out the film from the center toward the edges. Your drawing should be visible through the film.

3 Draw the Full-Size Sketch
Do your working drawing the same size as your intended painting. Using a no. 5B pencil, draw the contours of all the shapes onto heavy tracing paper. Once your composition is set, darken every line with the no. 5B pencil.

TIPS FOR WORKING WITH FRISKET FILM

� When peeling a large piece of film, enlist a helper so that you don't ruin it by getting it stuck to itself.

✖ Practice with scrap materials until you can cut the film without cutting the paper underneath.

✖ Your knife blade must be sharp to cut the film cleanly. As soon as a blade begins to drag, replace it.

✖ Before you discard a blade, wrap it in masking tape to prevent injury to whoever takes care of the trash (at my house, that's me!).

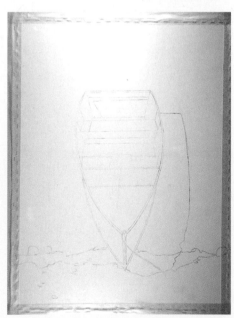

8 Darkest Values

(Each spraying stage is indicated by colored dots that correspond to the lettered steps. See the key on the facing page.)

A Referring to your value drawing, use a craft knife to cut the shapes for the darkest values (the rope shape and the shadows in the back of the boat, under the seat and along the left edge) out of the film and and remove them. This will expose the paper only in those shapes. Stick the opened atomizer into a jar of Phthalo Blue, your darkest value, and spray a couple of layers. Allow them to dry thoroughly. Next, spray a couple layers of Alizarin Crimson and allow them to dry thoroughly.

B Next, cut out the remaining dark shapes (the holes in the front seat, the large foreground shadow and the rock shadows). Leave a stripe of frisket covering the rope shape where it crosses the foreground shadow. Spray these areas with alternating layers of Phthalo Blue, Alizarin Crimson and Cadmium Yellow. Allow them to dry thoroughly.

C Cut out the large shadow shape on the right side of the boat. Spray this area with multiple layers of Opera, Phthalo Blue and Cadmium Yellow. Try to vary the color temperature within large shapes; the cool-to-warm transitions add interest.

You need not bring the darks to their final value at this stage. They will get darker as you spray the middle values later.

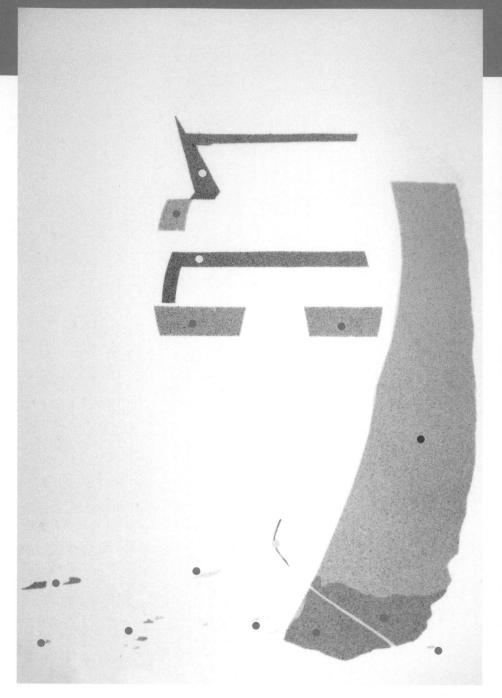

A MOUTH ATOMIZER IN ACTION *A workshop student uses a mouth atomizer to spray background color onto the unmasked portions of a painting.*

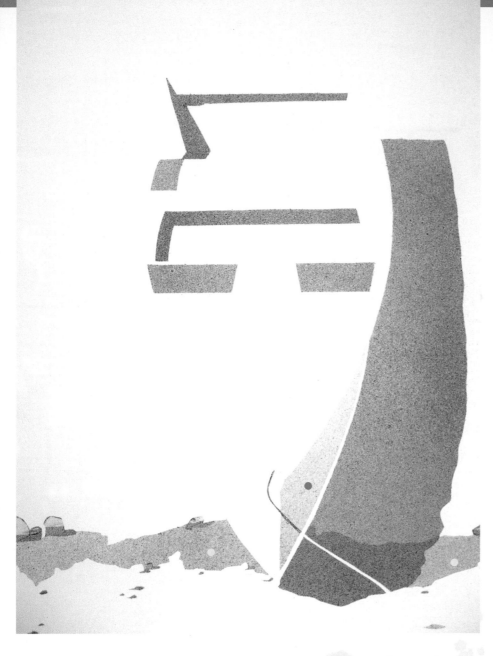

9 Paint the Shoreline Shapes

A Cut out the shoreline shapes. Be sure to cut around all the small rock shapes as you go; these rock shapes will be some of the lightest lights and should stay covered until the very end of the process. Working from the darkest to the lightest of the middle values, spray the shoreline shapes with alternating layers of Phthalo Blue, Alizarin Crimson and Cadmium Yellow. Use additional layers of Cadmium Yellow and Alizarin Crimson so that these shapes will be warm in temperature.

B Cut out the shadow shape to the right of the bow. Spray this shape with multiple layers of Opera and Phthalo Blue.

> **PAUSE OFTEN TO LET THE DOTS DRY** *When you spray with a mouth atomizer, do no more than three or four sprays before you let everything dry. Otherwise the little dots will merge and blend into an undesirable mottled texture.*

- = A
- = B
- = C
- = D

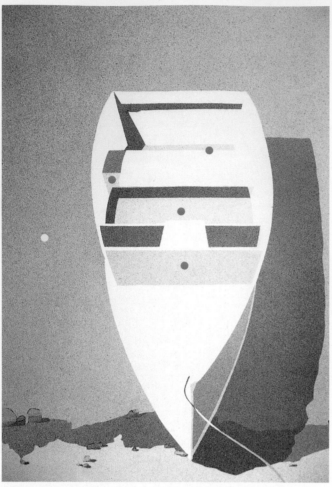

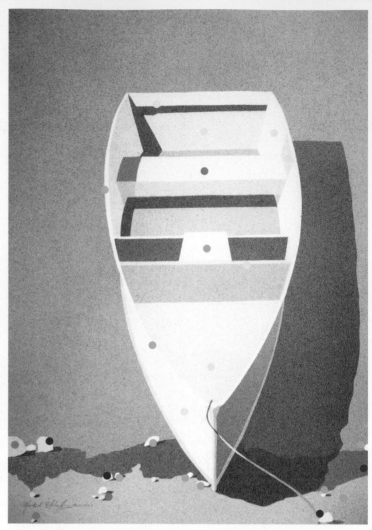

10 Paint the Water and Part of the Boat

A Carefully cut around the boat and remove the large piece of film that protects the water. Spray with alternating layers of Peacock Blue, Phthalo Blue and Cadmium Yellow. Useing more layers of spray in the upper left. Overlap each layer for a smooth transition. Your darkest shapes should get darker as you spray the middle values.

B Spray the front of the first seat as well as the floor behind it with Cadmium Yellow, then Alizarin Crimson, then a couple of layers of Phthalo Blue.

- ○ = A
- ● = B
- ● = C
- ● = D

11 Reveal the Light

Add water to the jars of Cadmium Yellow, Alizarin Crimson, Opera, and Peacock Blue, diluting the remaining paint by about one-half.

A Remove the film from areas that will be a bit darker than white (as shown). Stand farther back and spray these shapes with varying amounts of the diluted colors, blowing with maximum force to make smaller dots.

B Remove about one-third of the rock shapes and spray with a mix of equal parts Peacock Blue, Opera and Cadmium Yellow.

C Remove another one-third of the rock shapes and spray all the exposed rocks with the same mixture. (The first one-third of the rocks will become darker.) Let dry.

D Remove all remaining frisket film from areas that will remain white. Paint the rope line with a no. 2 round and a light-value mixture of Phthalo Blue and Alizarin Crimson.

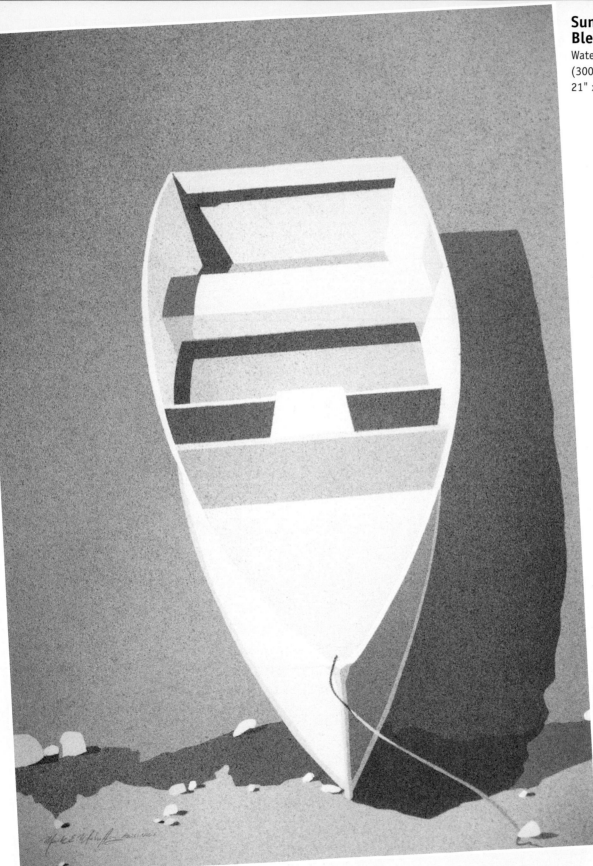

**Sun
Bleached #3**
Watercolor on 140-lb.
(300gsm) hot-pressed paper
21" x 29" (53cm x 74cm)

Lift Watercolor From Yupo

Yupo is a wonderful surface for artists who love to manipulate paint. The slick plastic surface makes it easy to add paint and even easier to remove or lift paint.

For this demonstration, we'll create an abstract work using various lifting techniques.

MATERIALS LIST

WATERCOLORS
Cadmium Yellow ✳ Indigo ✳ New Gamboge ✳ Opera ✳ Quinacridone Rose ✳ Ultramarine Blue

PAPER
Lightweight Yupo paper, 11" x 17" (28cm x 43cm) ✳ Another piece of Yupo to cut stencils and masks from

BRUSHES
¼-inch (6mm) and 1½-inch (38mm) flat ✳ No. 4 round ✳ Oil bristle brush for scrubbing

OTHER MATERIALS
Isopropyl alcohol ✳ Mylar ribbon with holes ✳ Bubble Wrap ✳ Masking tape ✳ Textured mat board ✳ A selection of water-soluble colored pencils ✳ Paper towels ✳ Craft knife

1 Clean the Yupo to Remove Fingerprints

Dip a paper towel into isopropyl alcohol and wipe the entire surface of the Yupo paper. The edges of the Yupo sheet are especially likely to have oil from your fingers, so wipe the edges vigorously. This illustration shows what will happen if you don't clean off those fingerprints!

Let the alcohol evaporate completely before you proceed.

● Bubble Wrap　　● Alcohol dropped into wet paint　　● Textured mat board

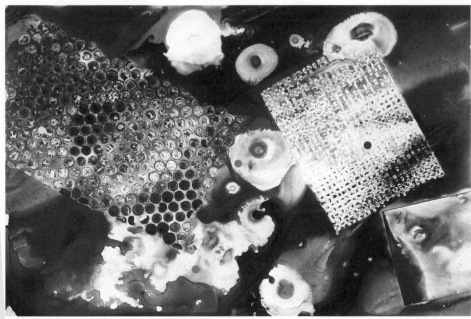

2 Create a Mass of Textures

Using a 1½-inch (38mm) flat and lots of water, apply large amounts of Indigo, Ultramarine Blue, Opera, Quinacridone Rose and Cadmium Yellow. Paint should completely cover the paper.

While the paint is still wet, press in rectangular pieces of Bubble Wrap and textured mat board as shown here, or any other texturing objects you would like to use.

Let the paint dry thoroughly, then remove the texturing objects.

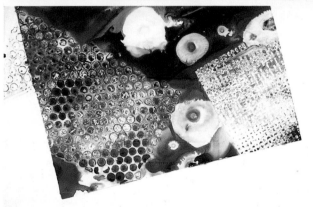

3 Remove Paint
Cut a rectangular piece of Yupo to serve as a mask. Lay it over your textured beginning, placing it asymmetrically within the larger rectangle. Use a paper towel dampened with water to wipe away all the paint around the mask.

4 Reveal a Rectangle
Remove the mask, revealing a painted rectangle within the rectangle of the picture space.

5 Add More Elements
A Triple-load a 1½-inch (38mm) flat with Indigo, New Gamboge and Opera. Make a fast, gestural stroke across the rectangle.

B While that stroke is still wet, scratch into it with the beveled handle of a flat brush.

C Float in light puddles of New Gamboge and Opera.

D On the bottom-right edge, paint a light neutral wash mixed from Indigo, Quinacridone Rose and New Gamboge.

E While that wash is wet, lay a rectangle of Bubble Wrap into it. Let the wash dry, then remove the Bubble Wrap.

F Add a line with water-soluble colored pencil in whatever color you prefer.

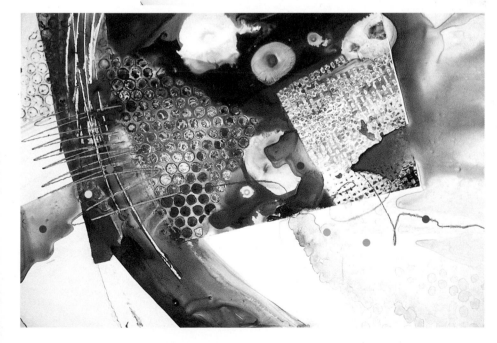

- ● = A
- ● = B
- ● = C
- ● = D
- ● = E
- ● = F

6 Lift to Subtract Elements

A Use a craft knife to cut a rectangular window out of another piece of Yupo. Lay the stencil across the top edge of the large main rectangle. Use a wet paper towel to remove the paint from within the rectangular window, then lift off the stencil.

B Make various-sized rectangular stencils and lift more rectangles around the right and bottom edges of the main rectangle. You can also leave a little paint instead of wiping it all away, in which case the lifted area will be slightly toned instead of white.

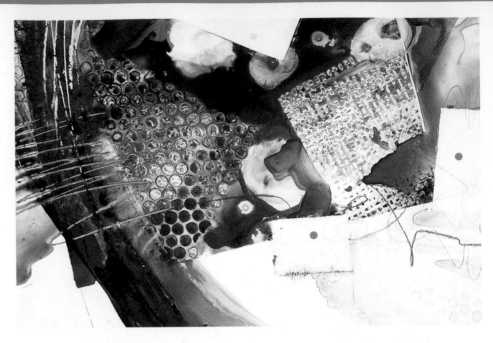

7 Create Layers

A Lay a piece of Mylar ribbon with holes along the right edge of the main shape, and use a wet paper towel to lift the paint out of the holes.

B At the upper left, lift another rectangle that breaks up the one lifted in the previous step. This time, while wiping through your stencil, leave about half of the pigment in place. The resulting rectangle will be a neutral midtone.

C Add some more gestural linework with water-soluble colored pencils.

D Use a no. 4 round to paint some intense accent colors within the lifted Mylar ribbon pattern.

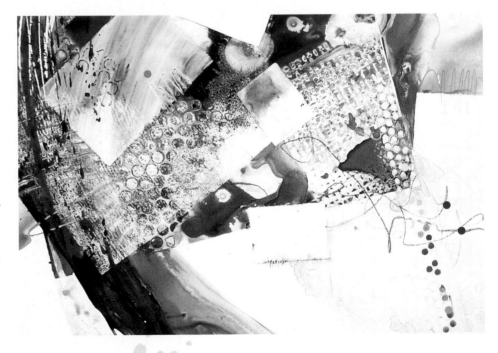

= A

= B

= C

= D

82

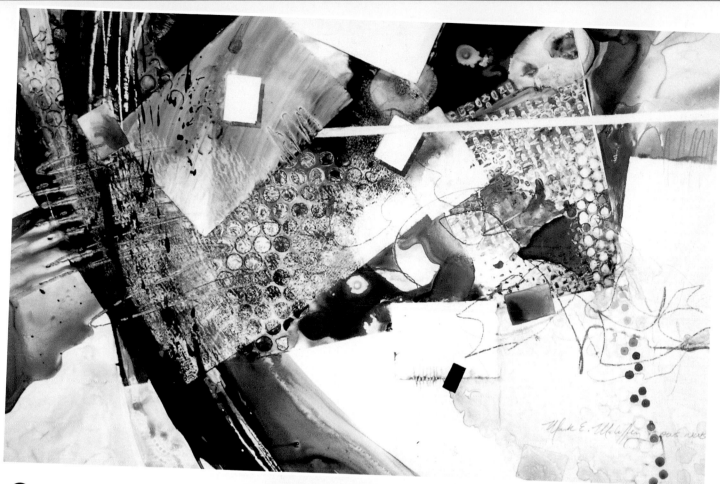

8 Lift, Add and Refine

A Make two small rectangle stencils and lift out five or six shapes with an oil bristle brush, scrubbing back to the white of the paper. Use a ¼-inch (6mm) flat with a good chiseled edge to add some intense color to a few of these lifted shapes. Use Indigo at full strength for a couple of the small rectangles for value contrast.

B Lay down two parallel pieces of masking tape and use a wet paper towel to lift all the paint from between them. End this line at the edge of a shape so that it appears to go under that shape.

Visual Layers, D
Mixed watermedia on Yupo
11" x 17" (28cm x 43cm)

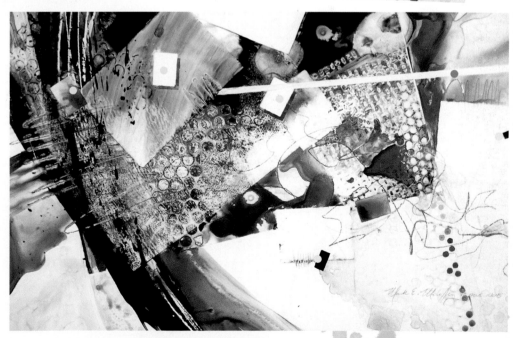

Enhance Watercolor With Other Mediums

I believe that practically any other medium can go with transparent watercolor. Admittedly, water-soluble mediums blend better with the water-soluble pigment and gum arabic binder that is transparent watercolor. Gouache, acrylic, casein, pastel, ink and water-soluble colored pencils all go into solution and blend readily with transparent watercolor. Some mediums are insoluble once dry, and some may be re-wet after drying, so it is best to experiment before incorporating other mediums in your transparent watercolor works.

Take a close look at the following paintings. They have mostly transparent watercolor, but other mediums were added to enhance the watercolor.

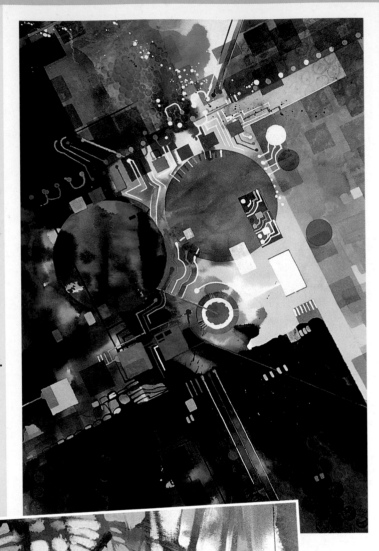

Cyber Worlds
Mark E. Mehaffey
Watercolor, acrylic and lightfast ink on 140-lb. (300gsm) cold-pressed paper
37" x 25" (94cm x 64cm)
Collection of Lansing Community College

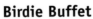

Birdie Buffet
Barb Hranilovitch
Watercolor under gouache on 140-lb. (300gsm) cold-pressed paper
12" x 16" (30cm x 41cm)

Slipstream

Michael Bailey
Watercolor, acrylic and
conte crayon on 300-lb.
(640gsm) Lanaquarelle
hot-pressed paper
22" x 30" (56cm x
76cm)

Geometric Storm Series #1

Mark E. Mehaffey
Watercolor and acrylic on 140-lb. (300gsm) cold-pressed paper
22" x 30" (56cm x 76cm)
Collection of Ken and Karen Stock

Try an Intense Acrylic Underpainting

Acrylic paint can work wonderfully with transparent watercolor. Look for fluid acrylic paint, which is designed to be mixed and diluted with water. Regular acrylics do not perform as well when diluted to a thin wash.

Diluted fluid acrylic paint will dry to a more intense color than the same amount of transparent watercolor, so an acrylic underpainting can seem to "glow through" the layers of transparent watercolor above it. Acrylic washes are also insoluble when dry; that is, a dry acrylic layer will not mix or go back into solution as dry watercolor will. That's very helpful if you have complementary layers of paint that would turn muddy if they were to mix during the painting process.

Let's try an acrylic underpainting to add intensity to a watercolor bay scene.

MATERIALS LIST

FLUID ACRYLICS
Hansa Yellow Light ✳ Transparent Red Iron Oxide

WATERCOLORS
Cobalt Blue ✳ New Gamboge ✳ Opera ✳ Quinacridone Rose

PAPER
300-lb. (640gsm) rough, 11" x 15" (28cm x 38cm)

BRUSHES
½-inch (12mm), ¾-inch (19mm), 1-inch (25mm) and 1½-inch (38mm) flat ✳ 1½-inch (38mm) nylon flat for acrylics

1 Create the Shaft of Light

Prepare a slightly diluted mixture of Hansa Yellow Light fluid acrylic plus a couple of drops of Transparent Red Iron Oxide to warm it. Use a 1½-inch (38mm) flat to wet the entire sheet of paper with water. (It may be necessary to go over the 300-lb. [640gsm] paper more than a few times to achieve the correct degree of saturation.) Allow the water's shine to just disappear, then start laying in the yellow wash vertically with a 1½-inch (38mm) nylon flat. Work from right to left, but skip over one narrow vertical area of the paper near the left edge of the painting. Then work left to right, again skipping over the unpainted area. The unpainted area represents a shaft of strong sunlight and will pass through the painting's focal point. Allow this wash to dry.

SAVE THOSE SABLE BRUSHES *Do not use your good sable brushes for painting with acrylic. Acrylic paint dries fast, and the last thing you want in the ferrule of a good brush is dried acrylic paint.*

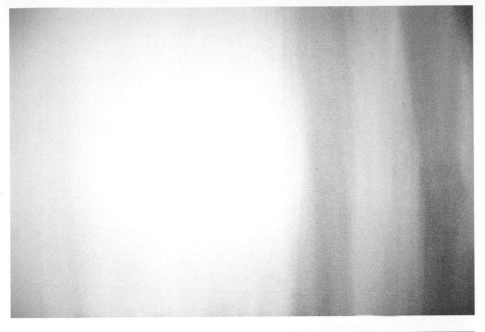

2 Add More Washes

Now that you're done with the acrylic paints, switch to your good brushes. Use a 1½-inch (38mm) flat to wet the entire sheet again. Remember, once the acrylic wash is dry, it is insoluble and will not intermingle with succeeding washes of transparent watercolor.

Let the shine just disappear, then paint washes toward the edges of the paper using diluted mixes of Quinacridone Rose and Cobalt Blue. Let the Cobalt Blue dominate toward either end of the painting. By making this wash slightly darker farthest from the light and allowing the strong yellow acrylic underneath to neutralize it, the shaft of light will appear that much stronger and lighter by contrast.

3 Paint the Tree Line

Make a diluted, cool-neutral mixture of Cobalt Blue plus Quinacridone Rose, Opera and New Gamboge. With a ¾-inch (19mm) flat and beginning at the left edge, start painting a tree line at the horizon. Manipulate the brush to create a jagged top edge. As you pass over the shaft of sunlight, lighten the value of the tree mixture by adding water. Before you paint your way out of the light area, charge in some intense Cobalt Blue to reinforce the focal area. As you continue toward the right, add a bit of Quinacridone Rose and Opera to the wash so that the tree line mixture gets warmer. Don't forget to make the trees get slightly larger as you proceed to the right edge. That and the warmer value will help the viewer perceive the trees as getting closer.

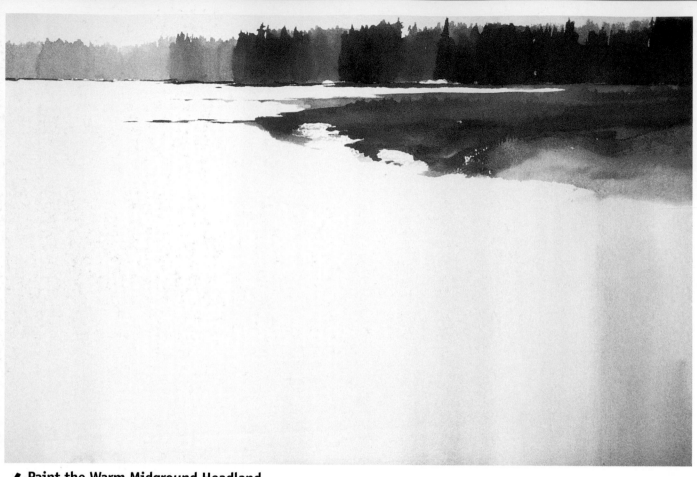

4 Paint the Warm Midground Headland

Using a ½-inch (12mm) flat with a good chiseled edge, paint the shoreline edge along the bottom of the tree shape; use a bold mixture of Opera and New Gamboge. Leave the underlying yellow wash visible in a few spots as a representation of rocks along the shoreline.

Continue down the paper, painting the midground headland and getting warmer as you go by adding more Opera and New Gamboge. As you get farther down, add Cobalt Blue to the mix to make a neutralized violet. Don't be afraid to let all three colors mix on the paper; that will give you a more exciting combination than if you blend the colors all together on your palette. Define the small islands that come out into the light from the midground headland by using the sharp edge of a flat brush.

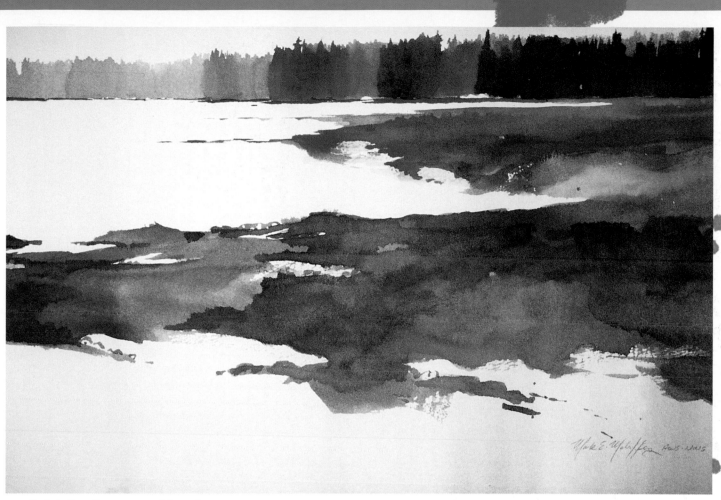

5 Paint the Foreground Landmass

Switch to a 1-inch (25mm) flat so you can carry more paint. Mix a strong violet out of Cobalt Blue and Quinacridone Rose. Neutralize a portion of this mixture by adding some New Gamboge. Mix more than you think you'll need.

Paint the entire foreground landmass with your large brush using both of the violet mixtures as well as some of the Opera and New Gamboge mixture from Step 4. Suggest rocks through variegations of color; create puddles by leaving a few gaps in the landmass. Don't add so much detail to the foreground that you pull interest away from the midground focal point: where the strongest color meets the white of the paper.

West on Big Bay Again
Watercolor and fluid acrylic on 300-lb. (640gsm) rough paper
11" x 15" (28cm x 38cm)

DEMONSTRATION
Use Pastel Over Watercolor

When pastel is applied to paper, its particles fill up the paper's "tooth" (the nooks and crannies of the paper surface). Transparent watercolor does not, so watercolor makes a perfect under-painting for pastel. Start with loose watercolor washes, then tighten up the painting with pastel or stay loose. The choice is yours.

MATERIALS LIST

WATERCOLOR
Cadmium Yellow Light ✳ Cobalt Blue ✳ New Gamboge ✳ Opera ✳ Quinacridone Rose ✳ Skip's Green

PAPER
140-lb. (300gsm) hot-pressed, stretched, 15" x 22" (38cm x 56cm)

BRUSHES
No. 12 round

OTHER MATERIALS
A selection of hard and soft pastels ✳ Workable fixative ✳ 5B pencil

1 Value Study
Do a value study in your sketchbook. Let the greatest amount of contrast be in the focal area (where the petals come together).

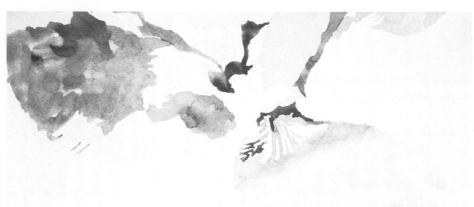

2 Do the First Washes
Pencil in the contour of all the shapes on the watercolor paper. Don't worry too much about abrading your paper with an eraser: The layers of watercolor and pastel will cover any eraser marks. Using a no. 12 round that comes to a good point, apply loose washes of Opera, Quinacridone Rose, New Gamboge and Cadmium Yellow Light. Use the point of the brush to work your way around the contours of the petals. Allow this to dry.

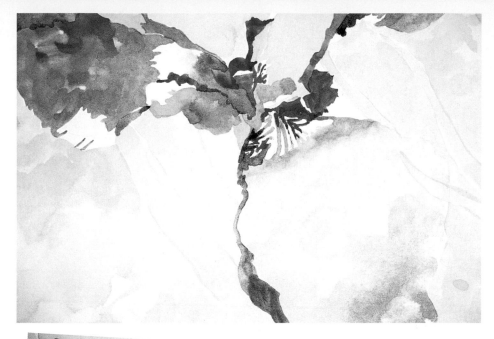

3 Fill the Paper With Washes

Continue painting loose washes using the mixtures from Step 1 until most of the paper is filled. Add some Cobalt Blue to the wash to darken the underpainting in the focal area, where the final value of pastel will be very dark.

4 Add Hard Pastels

Make loose strokes of hard pastel right on top of the watercolor washes. Choose for the petals a violet, a blue and a magenta pastel from your collection. Use an orange and a green to begin laying in the background shapes. Try not to get too tight at this stage; you can always resolve edges and details with the soft pastels later. Allow the watercolor underpainting to show through; it will act as the "glue" in terms of color unity to hold the many strokes of pastel together.

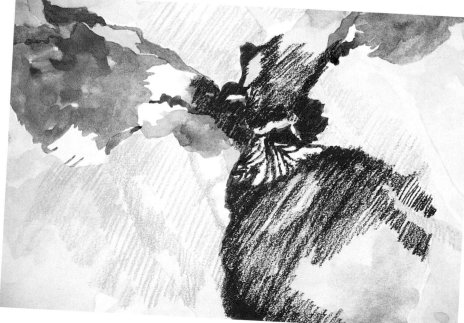

USE HARD PASTELS BEFORE SOFT *It is advisable to start with hard pastel and finish with soft. Hard pastel will not fill up the tooth of the paper as fast as soft pastel. This is especially important on hot-pressed paper, because the tooth of smoother paper fills up very fast.*

5 Finger-Smudge the Background Shapes

Still using the hard pastels, continue to cover the underpainting with quick, angled strokes. Add brown and light blue into the background over the layer of orange and green you applied in Step 4. Use your finger to gently smudge all the background shapes. This will visually push these shapes back and bring the iris forward.

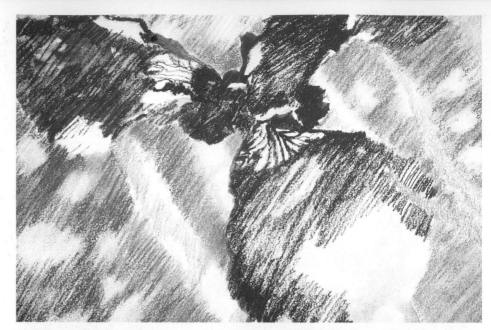

6 Switch to Soft Pastels

Start to slowly bring up the definition using soft pastels. In the dark areas of the iris, use a combination of dark blue and violet. Use an off-white and a light yellow to work around the center stamen area of the blossom. (Save your darkest blue-violet and your pure white for the next step.) In the background, use a layered combination of medium blue and orange (complements) and use your finger to smudge these two colors to achieve a neutralized color in most of the background. The neutral background will help bring the iris forward.

7 Finish

Press hard to lay down a thick layer of your darkest blue-violet soft pastel. Work it in and around the central area of the blossom. To give an indication to the viewer that the individual petals have some hills and valleys, make the valleys slightly darker. Use pure white, an intense orange and a brilliant pink to add small highlights where the light hits the left petal and the smaller shapes in the center of the iris.

Last, spray lightly with fixative.

Japanese Iris

Pastel over watercolor on 140-lb. (300gsm) hot-pressed paper
11" x 15" (28cm x 38cm)

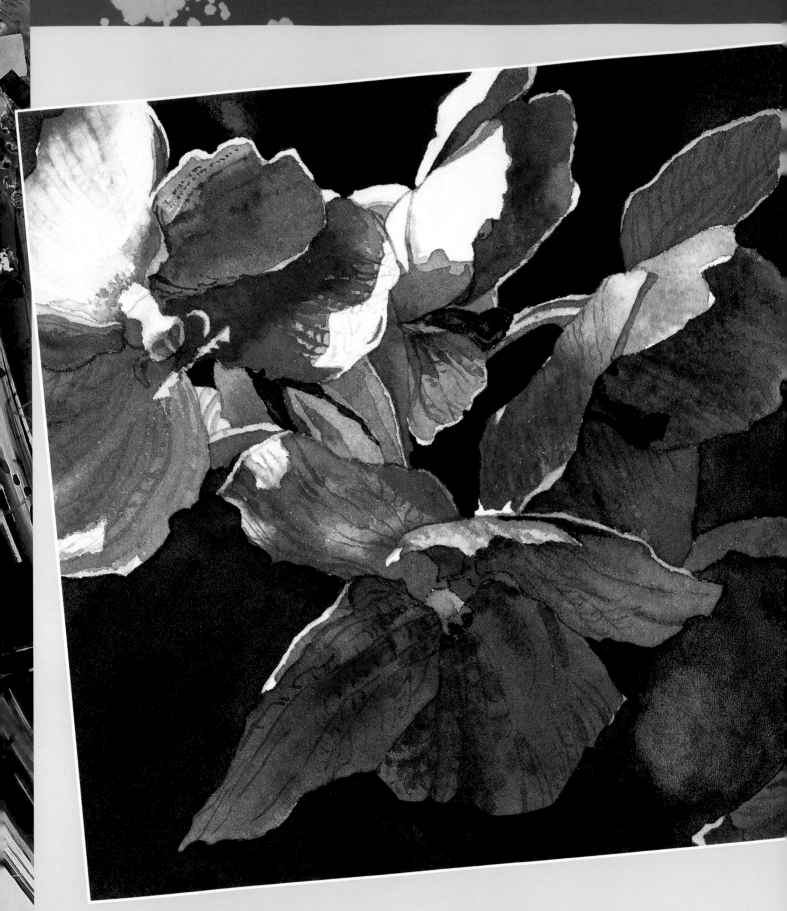

4 Break Through Artist's Block

Have you ever stared at a blank sheet of paper, unable to make that first stroke? Have you ever thought, "I'll never paint again"? Artist's block can take many forms. You might be paralyzed by fear of failure. Perhaps you ruined your last two painting attempts and are feeling inadequate. Or a rejection letter from that competition you desperately wanted to get into has you in a negative mood, and you can't bring yourself to fetch the morning paper, let alone paint.

You can survive all of the above and more. This chapter includes new painting techniques and strategies that are meant to be both inspiring and fun. Try them, and banish artist's block forever!

Hanging Orchids
Watercolor on Arches Liberte paper
6½" x 8½" (17cm x 22cm)

Paint on Supersaturated Paper

If you paint with the attitude that you have to be careful, your application of paint won't be powerful or spontaneous. A technique you can use to force yourself out of an overly cautious mode is painting on supersaturated paper. When all the paper fibers are soaked with water, the paint spreads aggressively.

This method came from Cheng Khee Chee, an artist I truly respect. He has done widely collected, award-winning paintings, and he is a sought-after teacher. He paints using many different techniques, something that has always seemed right to me.

MATERIALS LIST

WATERCOLORS
Cadmium Yellow Medium ✳ Indigo ✳ New Gamboge ✳ Quinacridone Rose ✳ Ultramarine Blue ✳ Winsor Red

BRUSHES
Nos. 6 and 10 round ✳ Large wash brush (or sponge) for wetting paper

PAPER
140-lb. (300gsm) cold-pressed, not stretched, 15" x 22" (38cm x 56cm)

OTHER MATERIALS
Nonabsorbent work surface ✳ Spray bottle filled with water ✳ Paper towels

● New Gamboge ● Ultramarine Blue + Quinacridone Rose ● Quinacridone Rose + a little Ultramarine Blue ○ Ultramarine Blue

1 Lay in Light Values

Put the paper on a nonabsorbent surface such as a countertop or a sheet of plastic. Use a sponge or a large wash brush to lay on lots of water. Turn the paper over and do this again. Repeat until the paper goes limp—that's when it's totally saturated. Use paper towels to mop up the excess water from around the sides of your paper.

With a no. 10 round, apply colors as shown. Keep this initial lay-in light in value. Do not allow this stage to dry. You can spray it with water and tilt your paper to get these colors to mingle and move across your paper.

HOW TO MAKE A BRUSH THIRSTY *A damp brush will actually lift more paint than a dry one. To make your brush thirsty, completely soak it in clear water, then use your fingers to squeeze out most of the water until the brush is damp but not wet. The thirsty brush will now lift the maximum amount of pigment.*

- ● Quinacridone Rose + a little Ultramarine Blue
- ● New Gamboge
- ● Ultramarine Blue
- ● Ultramarine Blue + Quinacridone Rose

2 Define the Forms With Dark Values

Use heavy mixtures of the colors specified at left to create the forms of the composition. When you work on highly saturated paper, you're diluting your pigment twice: once on the palette and again on the paper. Take this into account and mix your colors stronger than you normally would.

Don't worry about losing all the white of your paper or the colors running together.

3 Reveal the Shapes

Use a thirsty no. 10 brush (see the sidebar on the facing page) to lift the shapes of the tulip petals. Start with the smallest of the petal shapes. Since your paper should still be very saturated, the paint should tend to run back into the shapes you lift. Keep at it— you may have to lift each shape several times before the paper dries enough for the shapes to hold.

Each time you lift pigment, swish the brush in clear water to remove the paint you just lifted; otherwise you'll redeposit that pigment on your painting. Keep lifting and swishing until your shapes begin to hold.

Add small amounts of strong Quinacridone Rose and some New Gamboge back into the lifted petals. Mix a neutral using all three colors and use this to define the insides of the blooms.

Midnight Tulips
Watercolor on 140-lb. (300gsm) cold-pressed paper
11" x 15" (28cm x 38cm)

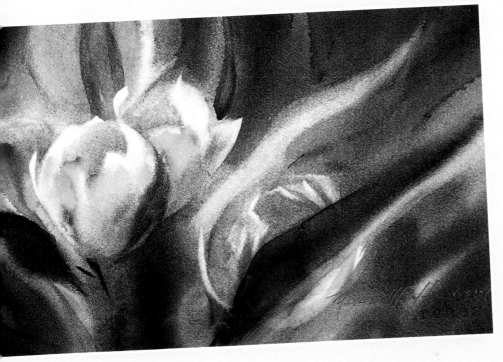

Let One Painting Inspire the Next

When you're feeling stuck, see if one of your old paintings contains something you can borrow and take in a new direction. If something is worth painting once, it's worth painting again. Perhaps painting the same subject with a different color scheme or value pattern would produce a completely different look.

Try painting at least six works around a certain subject or theme. The relationship between the paintings can be as simple as a recurring color or as complex as your feelings about an important issue. After creating that many paintings, you will begin to distill your imagery down to just its essentials—those visual marks and passages that have meaning for you—leaving out passages that don't contribute to your theme.

By painting this way, you'll start learning to "speak" in many voices. Don't fret about those who say you must find your "voice" as an artist and then stick with that forever. Part of being an artist is inviting change.

Here I present a series of my own nonobjective paintings that spans about twenty years, with notes on how one led to another. Where might one of your old paintings lead you?

1983
Before the 1980s, my studio work was almost all landscapes, still lifes and florals. My wife and I were early in our careers and needed the income from these universally salable images. But inevitably, I sought new subjects. Since I loved to fish and spent a lot of time looking down at stream bottoms, I thought, "Why not paint them?"

Brook Trout
Watercolor on 300-lb. (640gsm) cold-pressed paper: 21" x 29" (53cm x 74cm): Collection of Larry and Dani Cross

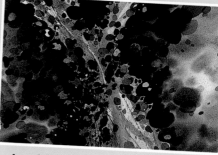

Looking Down
Watercolor on 140-lb. (300gsm) cold-pressed paper: 21" x 29" (53cm x 74cm)

1980 **1985** **1990**

Late 1980s, Early 1990s
The organic shapes in my paintings of stream bottoms had worked well, so I figured the same arrangements could work for geometric shapes.

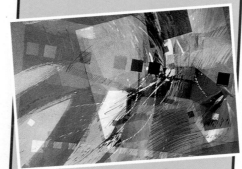

Geometric Storm Series
Mixed watermedia on 140-lb. (300gsm) cold-pressed paper: 27" x 36" (69cm x 91cm)

Early 1990s
I seem to have moved from looser to tighter within a series. As I continued to manipulate geometric shapes, my compositions grew more complex. I imposed more structure upon each whole and held the compositions together with patterns both painted on and pressed in. I tried texturing with Bubble Wrap, a texture I still like using more than ten years later!

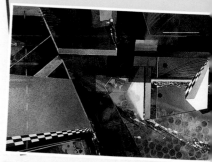

Teeter Totter
Watercolor on 140-lb. (300gsm) cold-pressed paper: 22" x 36" (56cm x 91cm)

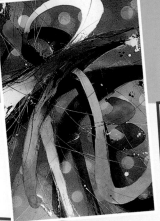

Kanji: Flower
Mixed watermedia
on 140-lb. (300gsm)
cold-pressed paper:
37" x 29" (94cm x
74cm)

Mid-1990s
One year when I taught high school art, I had a Japanese exchange student who would do kanji brush calligraphy during class. It was great for my inner-city kids to see how important a brush was to someone from another culture. I even followed along with my brush. My young tutor said my characters *looked* great but I did them all wrong!

The result of all this was a series of paintings, some quite large, that handled kanji characters as shapes in space. Gesture and line were also important in these works.

Later 1990s
In the previous example I had a rectangle sticking into the picture space. In this painting, the rectangle floats within the picture space. I did more pouring and less patterning, and I added a representational element.

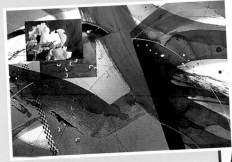

Iris and Elements
Watercolor on 140-lb. (300gsm) cold-pressed paper: 27" x 39" (69cm x 99cm)

2002–2005
The rectangle rules! Rectangles form the major shape. I applied textures with stencils, packing material and found objects. Rectangles are subtracted, wiped out through stencils, and added with a brush. Gestures and lines are done with a brush and colored pencils.

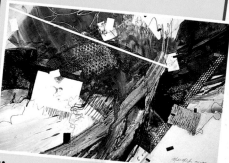

Visual Layers
Mixed watermedia on Yupo:
23" x 29" (58cm x 74cm)

1995 **2000** **2005**

Late 1990s
Around this time the teachings of artist Maxine Masterfield hit my consciousness, specifically her use of high-intensity, lightfast inks and the technique of pouring those inks. Imagine giving up control and *pouring* paint! I added a geometric shape from my previous work and went to town.

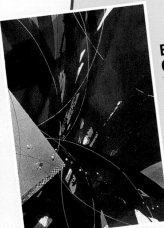

Elements in Opposition, Red #7
Mixed watermedia on 140-lb. (300gsm) cold-pressed paper: 42" x 26" (107cm x 66cm)

Early 2000
The geometric shape became dominant. The pours were just about gone, replaced by gestural strokes done with very large brushes. The rectangle within a rectangle within a rectangle was never a favorite compositional device of mine, but it's evident in this work.

Mayan Legacy 2
Watercolor on 140-lb. (300gsm) cold-pressed paper: 41" x 32" (104cm x 81cm)

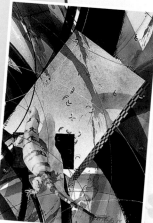

Develop Several Paintings at Once

Drop paint onto a wet surface, drag a dry brush across dry paper, do a graded wash, lift paint with a paper towel, lay in random shapes—all at the same time!

OK, maybe not exactly at the same time, but one of the best ways to spark your creativity is to do a bunch of starts at once. Don't pressure yourself to come up with great paintings. Sometimes you will, but most of the time you won't. Just try to do the best job you can with each one. The extra practice will sharpen your skills and may even inspire a larger and better painting.

Try it with me. Shown here are the six starts I did and how I finished them. You can emulate the starts shown here then come up with your own unique finishes for each one, or do your own thing from the beginning.

1. Get Six Pieces of Paper
Lay six pieces of paper all together on your work surface. Place some of them horizontally and others vertically. Secure all the edges to the work surface with masking tape.

2. Paint Six Starts
Thoroughly wet some of the six pieces with a ³/₄-inch (19mm) flat. Leave others dry.

Vary your starts: Drop paint onto wet paper; do a loose sky with no plan for the land; do a graded wash; spatter paint; lay in a heavy amount of paint. Use a tissue to lift off some paint; paint scattered shapes reminiscent of landscape forms. Copy my starts or create your own; it's up to you.

Wet-Into-Wet

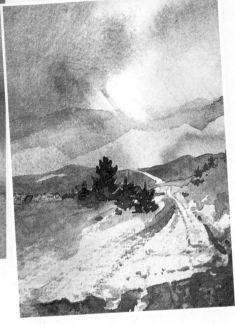

Finish

Graded Wash

Finish

Lift It Out

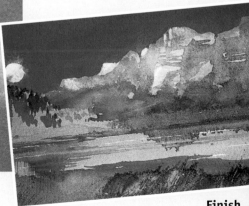

Finish

Drop It In

Finish

3. Finish

Use a ³⁄₄-inch (19mm) flat, a ¹⁄₄-inch (6mm) flat and a no. 6 round to finish all of your starts. Skip around: Do a little on one, then go to another. Dry some with a hair dryer to accelerate the process. Some you may finish in one pass; others you may come back to multiple times. Keep going, trying to bring each start to some kind of resolution.

Will all your finishes look good? No (not all of mine do either!), but every now and then you will get a jewel of a painting. That alone will be worth the effort. Another benefit of this exercise is that it teaches you to work under pressure. As you go from one piece of paper to the next, mixing paint, adding a passage here, drying, then lifting paint there, you practice the decision-making skills you need when you attack a full-size sheet.

You never know when one of these small, fun studies will send you in a whole new direction!

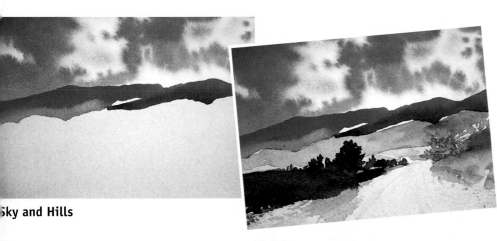

Sky and Hills

Finish

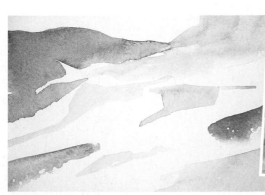

Scattered Shapes

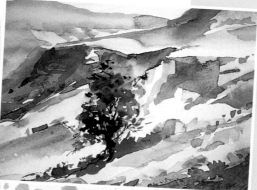

Finish

Paint a Sumi-e Heron

If you're overwhelmed by the idea of a large project, try a style of painting that uses very few brushstrokes: sumi-e.

Japanese sumi-e, or monochromatic ink painting, goes back thousands of years. I'm not an expert: sumi-e artists spend a lifetime in practice and meditation. But I love the simplified forms, the flattened perspective, and the gestures that seems to capture a moment with a brushstroke. Most of all, I love the quiet emotion and the serenity of a well-executed sumi-e painting.

Sometimes I grind my own sumi ink and use sumi brushes on rice paper. More often, as in this demonstration, I use watercolor paper and brushes and simulate sumi ink with watercolor. If you want to experiment, by all means try the traditional materials.

MATERIALS LIST

WATERCOLORS
Indigo ✳ New Gamboge ✳ Phthalo Blue ✳ Winsor Red

PAPER
140-lb. (300gsm) hot-pressed, 7" x 4" (18cm x 10cm)

BRUSHES
Nos. 4 and 10 round

SIMPLIFY YOUR VALUES
When painting in sumi-e style, mix ink or paint in three values— a dark, a medium and a light— and simplify your world into those values.

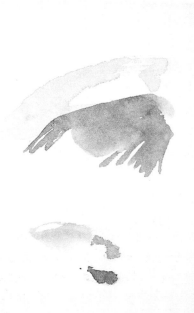

1 Light-Value Gesture

Mix Indigo with just a touch of Phthalo Blue for a cool ink color. Mix this with very little water on your palette. This puddle will be your darkest value. Pull aside a little of the dark color and mix it with lots of water to make a very light value. Using the light-value mixture and a no. 10 round, make a fast stroke diagonally across the paper. This stroke represents the outstretched wing on the far side of the heron. Allow this to dry.

2 Tail, Wing and Rocks

Still using a no. 10 round, mix a medium-value puddle and quickly paint the tail, the near wing and the rocks. Keep the number of brushstrokes to a bare minimum.

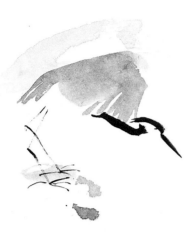

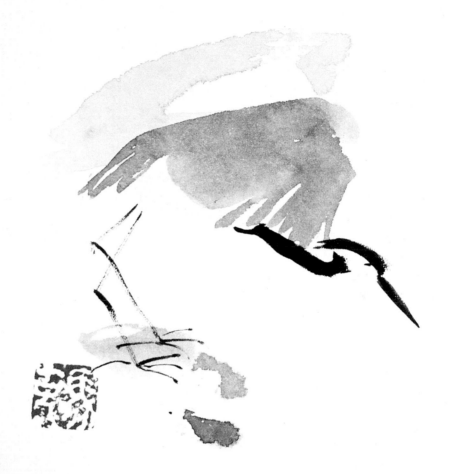

3 Head, Neck and Legs
Switch to a no. 4 round and paint the feet, legs, head and neck using the the dark puddle of paint you mixed in Step 1.

4 Your Chop
Sumi-e paintings are usually signed with a "chop," a stamp that represents the artist's signature. Kits are available with which you can carve a chop based on calligraphic characters or any design or symbol that has meaning for you. The placement of the chop should help define the space without seeming separate from the whole.

Usually sumi-e artists dip the carved stamp into special Vermilion ink. Here I used a mixture of Winsor Red and New Gamboge to approximate that color.

Heron
Watercolor on 140-lb. (300gsm) hot-pressed paper
7" x 4" (18cm x 10cm)

DEMONSTRATION
Paint a Sumi-e Forest

To give you a better idea of what you can do in the style of sumi-e, here's another example: a forest scene. As you do this project, think to yourself, "How few brush-strokes can I use to describe a pine forest?"

Materials for this are the same as those listed on page 102.

1 Make a Light-Value Start
Use a no. 10 round and a little water to mix a dark puddle of Indigo on your palette. Pull aside a small amount of this and mix it with lots of water for a very light value. Lay the strokes down as fast as you can to capture just the essence and nothing else. Allow this to dry.

2 Lay in the Middle Ground With the Middle Value
Still using a no. 10 round, mix a medium value "ink." Indicate two pine trees in the middle distance; they'll seem to come forward because they are larger and darker than the strokes used for the first pass. Try to give the viewer just enough information to suggest pine trees.

3 Add a Dark-Value Element
Use just the tip of a no. 4 round and your darkest mixture of Indigo to paint a thin line that has the look of a lone pine, long dead, standing guard just a little apart from the rest of the forest.

Since I chose to make the tip of this lone pine lean to the left, I placed my chop in the lower right to help balance the composition.

Old Pine Forest
Watercolor on 140-lb. (300gsm) hot-pressed paper
4" x 5" (10cm x 13cm)

Go "Cloud Watching" in an Underpainting

Let's just say I'm over fifty, but I still love to watch clouds. I have fun imagining all sorts of creatures, faces and objects in them as they go by.

In this project, you'll find shapes within "clouds" of paint. Specifically, you'll do an underpainting of light-value washes, then look for shapes in that underpainting. Whatever you see in the paint clouds will be the subject of your painting. You'll use negative painting to reveal shapes (see page 54 for more on negative painting).

MATERIALS LIST

WATERCOLORS
Cobalt Blue ❋ New Gamboge ❋
Quinacridone Rose ❋ Winsor Red

PAPER
140-lb. (300gsm) cold-pressed, stretched, 22" x 15" (56cm x 38cm)

BRUSHES
1/2-inch (12mm), 3/4-inch (19mm) and 1-inch (25mm) flat

1 Do the Underpainting

Use a 1-inch (25mm) flat to flood the paper with clear water. Wait until the shine has just started to disappear, then brush on random strokes of Cobalt Blue, Quinacridone Rose, and a violet made from those two colors plus New Gamboge. Allow this to dry; use a hair dryer if you want it to dry quickly.

Take a long look at the result. Turn the paper in every direction. Do you see something? Part of something? Keep looking, and something will become evident to you. In my underpainting I saw a complicated bloom and abstracted leaves and stems with strong light coming from the right.

2 Begin to Define the Subject

Mix slightly darker versions of the colors you used in Step 1. With a 1-inch (25mm) flat, cut in around the large bloom that will be the focal area. The underpainting here is a strong Quinacridone Rose, so make that mixture only slightly darker than in the previous step. As you work to the right, the underpainting changes to a violet made with Cobalt Blue and Quinacridone Rose; switch wash colors as you go. Define the edges of the leaves and stems. Switch to the lower-right corner and define that area with washes of New Gamboge and a violet mixture. Allow all of this to dry completely.

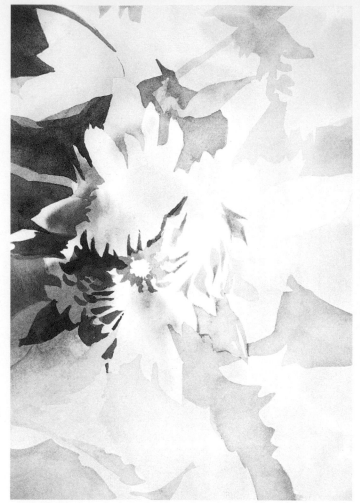

3 Bring Out More Detail

Usually, as one progresses from larger to smaller shapes in a painting, one uses smaller brushes. In this painting, for a looser, unlabored look, stay with a 1-inch (25mm) flat as long as possible.

Mix slightly stronger washes of the same colors you used in Step 2. Move to the lower right of the painting and define some of the leaf and stem shapes. Occasionally let one side of a stroke define a shape negatively while the other side of that same stroke becomes a positive edge for another shape.

Move back to the top of the painting, which should be dry by now, and use an even stronger, darker wash to re-define some of the leaf shapes. Create one stem by painting around it; add another stem by painting it in. Allow all of this to dry.

4 See the Bloom, Paint the Bloom

Switch to a ¾-inch (19mm) flat. Mix strong puddles of Quinacridone Rose and Winsor Red on your palette. Begin on the left edge of the focal area, the bloom, and paint the small shapes that form the petals. As in Step 3, use one stroke to paint one side of a petal and define the negative space around another petal. Vary the temperature of your reds: Let some of the petals lean toward cooler Quinacridone Rose, and let other petals lean toward warmer Winsor Red. As you move to the right within the bloom, let the values get dramatically lighter. This will create the illusion of light coming from the right.

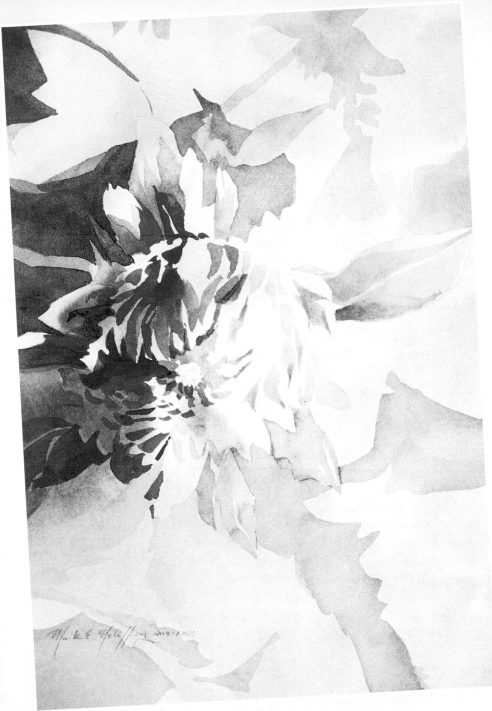

5 Add the Drama

Use a ½-inch (12mm) flat to directly paint more petals within the bloom. The petals on the left are away from the light and should be quite dark. As you move toward the the right side, make the petals lighter. As in Step 4, vary the temperatures of the reds. Continue around to the light side of the bloom, adding petal shapes. Directly paint a couple of leaves. Also add an accent of stronger Cobalt Blue to the edge of the flower to help pull the viewer's eye away from the bull's-eye created by the circular center of the bloom.

Clouds to Flower
Watercolor on 140-lb. (300gsm) cold-pressed paper
22" x 15" (56cm x 38cm)

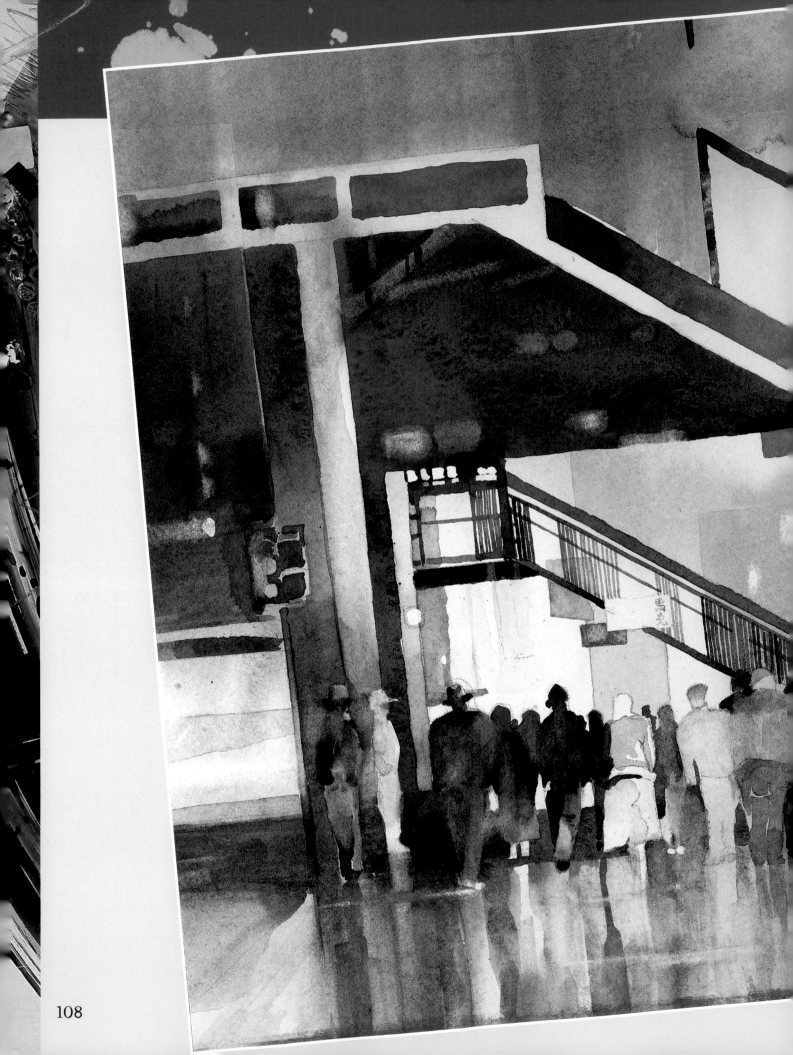

5 Be a Creative Problem Solver

Theoretically, we artists should be able to spot problems with composition or technique as we go and make the needed corrections. It should be a simple matter. The reality is just the opposite. It can be very difficult to spot one's own problems, especially design problems. Find a good instructor whose opinion you trust, and listen to what that person has to say. A critique group is another way to go; just make sure that your group includes some experienced artists who are willing to be brutally honest. It does you no good to hear only how much another person likes one of your paintings. Conversely, it is possible to say something good about all works; avoid the entirely negative reviewers who do nothing but feed their own egos by cutting all paintings to ribbons.

Remember, a critique represents one person's opinion. You are free to take the advice or ignore it. The best thing you can do to solve your painting problems is to keep painting.

In this chapter we'll look at some student works to see what is good about them and what could be improved. We'll learn ways to strengthen or even redo a painting. We'll also examine some very successful paintings and hear from the artists themselves what they did to make each painting work.

Chicago Rain
Watercolor on gessoed
140-lb. (300gsm) cold-
pressed paper
30" x 22" (76cm x
56cm)

What's Wrong With My Painting?

Painting is the ultimate responsibility. No one else is responsible for what happens on your paper, and you live with and learn from your decisions. Constructive criticism can help. Take critiques with a smile and a thick skin. Not all the criticisms you hear will be helpful; listen for and use the ones that can help you make better paintings.

Following are several graciously supplied student paintings with my comments on what's done well and what could be changed to make the paintings stronger.

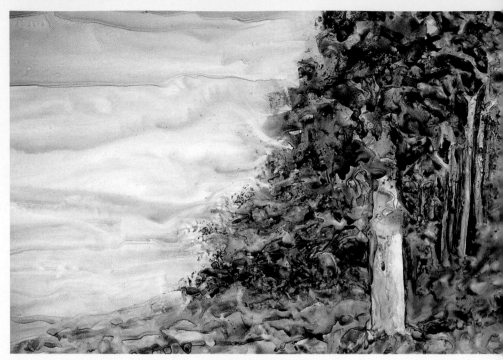

Vary the Large Shapes, Textures and Temperatures for More Interest

The artist has divided up the picture space almost equally between the negative shape of the sky and the positive shape of the tree and forest. Breaking up the picture space asymmetrically would have made the large aspects of the work less static, allowing this artist to explore the smaller details of the image to greater advantage.

The placement of the focal area, the largest tree trunk, is fine, and the repetition of the smaller trees does lead the eye toward the largest trunk. However, because painting on Yupo paper produces wonderful textures almost automatically, it is easy to overdo texture on Yupo. The artist has used similar textures for all the leaves and the entire foreground. A variety of textures with some variation of color temperature would create more interest in this area.

Yupo Landscape
Student

Keep the Viewer's Eye Within the Painting

In this painting and collage the artist has done a great job of using a misty, neutralized color scheme to achieve a subdued mood. The collage mountain shapes work well and do not come forward in space too dramatically.

However, the foreground shape, which is hand-painted watercolor paper glued into place, acts as an arrow pointing to the lower left; it directs the viewer's eye out of the painting. The edge of the foreground shape also happens to hit almost exactly at the corner of the composition, splitting the picture in half diagonally. Raising this shape would not only keep the viewer's eye within the painting but would also give the artist more room at the bottom for a textural element built up with collage.

In the Valley
Student

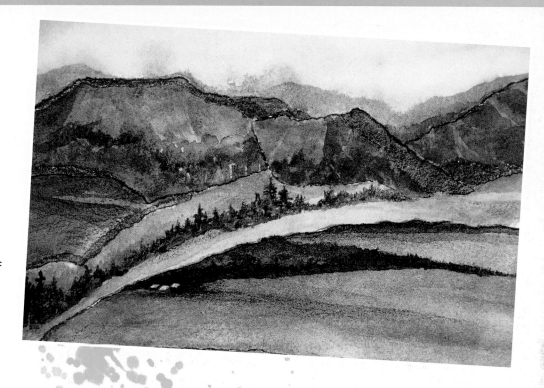

Leave Out What Doesn't Support the Story

The arrangement, variety and linking of shapes are done well with one major exception: The top edge of the leaf in the upper-right quadrant is parallel to the top edge of the paper. A more diagonal placement would be less static and more exciting.

This artist handles the detail within the leaves wonderfully and tells that visual story well. However, I think the vase and the table edge are unnecessary. Without them, the painting would better communicate what the artist was most interested in. Also, all of the leaves have the same high degree of detail. By omitting some of the texture and detail away from the focal area, the artist could create some mystery for the viewer, thereby involving them in the process of discovery.

Begonias
C. Evans

Decide What's Most Important

This artist has good technical skills. Her brushwork and texture representations are appropriate for the subject. The placement of the dominant vertical pine tree is good: slightly off center toward the right.

But as a viewer, I struggle to understand what the artist is trying to tell me. Is this painting about the pattern and texture of the pine bark? Is it about the detail of the needles that occupy the upper edge? Is this painting about the layers and textures of the background rocks? The artist could better communicate a single vision by choosing one of these competing elements, then subordinating or eliminating everything else. The work has many pluses and would make a great series of paintings. By doing a series of works, the artist would eventually distill out those elements that are most important and gradually leave out those that are not.

Southwest Pine
C. Evans

Place and Overlap Edges for a Better Composition

This artist has a good understanding of how to handle brush, paint and paper, but the bottom edge of the vegetables cuts the paper diagonally in half. The bottom edge of the shapes would work better if it were dropped down somewhat.

Another awkward edge is the bottom edge of the eggplant where it meets the other vegetables. Overlapping the eggplant shape with the shapes of the other vegetables would tie all of these shapes together and give the viewer a clue about exactly where each shape is placed in space.

Drawing this composition many times in a sketchbook would allow the artist to work out issues such as these before starting to paint.

Veggies
B. McGinnis

Use Dominance to Unify

The artist does a nice job of blending and modeling the forms to give the impression of roundness. However, the artist has tried to say too much. The central tree, the tree on the right edge and the rocks in the foreground all fight for dominance.

There is also almost a fifty-fifty split of warm and cool colors: warm browns and yellows in the lower half, cool green and blues in the upper half. Letting the painting lean one way or the other would unify the whole.

As in *Veggies* on the facing page, there are some awkward edges. The left edge of the dark tree hits the right edge of the central tree trunk. The upper-right edge of the central rock hits the edge of the path. The artist could overlap these edges to better link the shapes.

Landscape Impressions
B. McGinnis

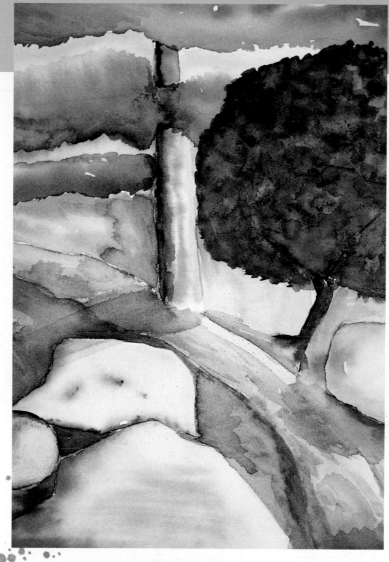

Add the Dominant Color's Complement

The artist has done a portrait of a single flower. There is unity of color because the artist has used a safe, analogous color scheme: yellow, green and blue. Adding a bit of orange—the complement of blue, the dominant color in the painting—would create a visual vibration and make this painting stronger.

The center of the bloom acts like a bull's-eye because it is uniformly hard edged and falls near the middle of the paper. The artist could move the flower's center farther to the right and soften an edge within the small dark important shape.

Lily
B. McGinnis

113

DEMONSTRATION
Use Acrylics to Strengthen Weak Areas

My paintings fall into three categories: those in which I accomplished the visual goals I set for myself and which are more or less successful, paintings that were not quite failures but will not be shown, and my failures! The "not quite failures" are candidates for improvement with acrylics.

Follow along as I re-work one of my old watercolor paintings with acrylic. Then try these techniques on an old painting of yours that you wish was stronger.

MATERIALS LIST

A painting
that could use a facelift

FLUID ACRYLICS
Hansa Yellow Medium ❋ Titanium White ❋ Transparent Red Iron Oxide ❋ Turquoise (Phthalo)

MEDIUM VISCOSITY ACRYLICS
Bright Aqua Green ❋ Cadmium Yellow Medium ❋ Raspberry ❋ Ultramarine Blue

HIGH VISCOSITY ACRYLICS
Mars Black ❋ Naphthol Crimson ❋ Phthalocyanine Blue ❋ Ultramarine Blue

BRUSHES
2-inch (51mm) and ½" (12mm) nylon flat ❋ 1-inch (25mm) bristle ❋ ½-inch (12mm) flat bristle

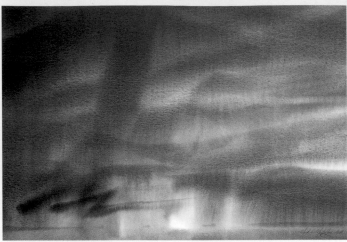

1 The Perfect Candidate
This transparent watercolor was done wet into wet on a brand of cotton rag paper I no longer use. I felt that the paper absorbed too much of the pigment and made my colors appear washed out. I also could have used a much stronger, more saturated application of paint.

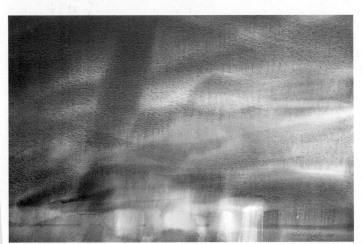

2 Enhancement of the Horizon Focal Area
First I used a 2-inch (51mm) nylon flat to wet the entire sheet. I let this water soak in, then did another application of water. (Re-wetting an old watercolor painting in this way will not greatly loosen the pigment, as long as you don't scrub.)

After the shine of the water disappeared, I used Hansa Yellow Medium and Titanium White fluid acrylics in vertical strokes from the lower part of the sky over the horizon line down onto the water. Those strokes began to establish vertical reflections to define the water. I allowed this layer of acrylic to dry completely.

DON'T BE AFRAID TO ADD STRONG COLOR *When you start adding acrylic to a watercolor painting, the acrylic color will look very strong compared to the transparent watercolor, but remember, that's what you're after—a stronger painting.*

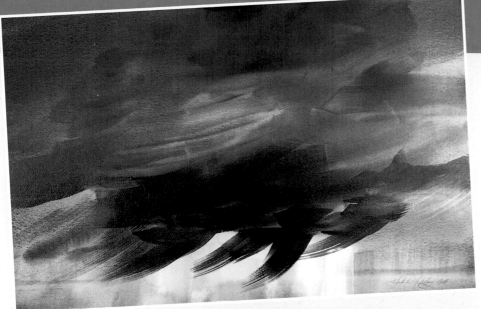

3 A Stronger Sky

I mixed Ultramarine Blue with small amounts of Transparent Red Iron Oxide and Raspberry acrylics, blending with very little water to get a very dark value of a slightly neutralized blue. With a 2-inch (51mm) nylon flat brush and quick, broad strokes, I darkened the whole sky. Using the same mixture and the same brush, I then painted angled strokes that sweep down from the sky. The angled strokes indicate distant rain.

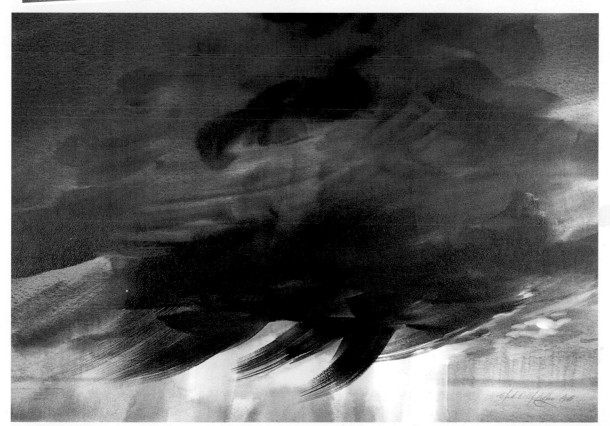

4 More Drama

I mixed Ultramarine Blue and Phthalocyanine Blue high-viscosity acrylics with a little Naphthol Crimson high-viscosity acrylic. I added this darker value to the upper portion of the entire sky because I didn't want the darkest part of the sky (near the horizon) to look isolated.

I added some Titanium White to the cloud mixture to make a medium-value, slightly neutralized blue-violet. With this mixture and a ½-inch (12mm) flat, I added some small clouds along the horizon line just to the right of the rain clouds. This is the focal area of the painting, and I wanted some smaller shapes here to attract the viewer's eye.

MOVE THICK ACRYLICS WITH A STIFF BRUSH *When applying thick acrylic paint to add punch to a watercolor, use an oil painting bristle brush. The stiff brush will help you move the thick paint around.*

5 Sky and Water

For the water, I mixed Cadmium Yellow Medium and Bright Aqua Green. Working left to right with a 1-inch (25mm) flat, I laid a small amount of this green below the clouds. Moving right, I added vertical strokes of Ultramarine Blue mixed with a little Phthalocyanine Blue and Naphthol Crimson, then a streak of Cadmium Yellow Medium mixed with Naphthol Crimson, followed by a larger shape of dark blue-violet. Below the lightest area of the sky, I painted a reflection with a mix of Cadmium Yellow Medium and Titanium White.

I mixed medium-value neutralized violet with Ultramarine Blue, Naphthol Crimson and a small amount of Cadmium Yellow Medium. I painted this right along the horizon to give the viewer an indication of the distant shoreline and islands.

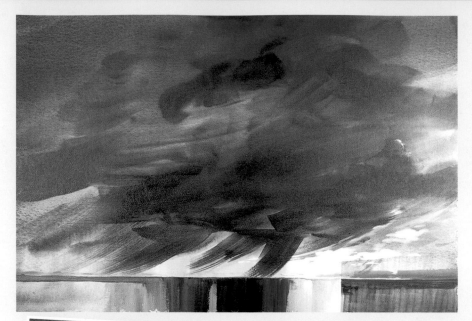

6 The Lightest Light and the Darkest Dark

Using a ½-inch (12mm) flat bristle brush and a mixture of Camium Yellow Medium and Titanium White, I painted the right edge of the large yellow reflection. With that same yellow I added just a hint of light hitting the edge of the largest clouds from the right. To finish, I mixed a very small amount of black with Ultramarine Blue and added this dark accent immediately to the right of the lightest vertical reflection.

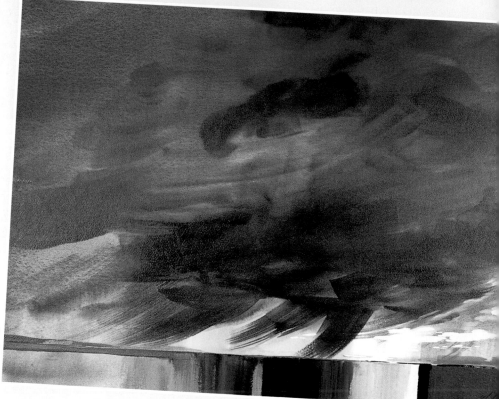

Approaching Storm
Acrylic over watercolor on 140-lb. (300gsm) cold-pressed paper
22" x 30" (56cm x 76cm)

Make Powerful Changes in Gouache

Gouache is opaque water-color. It contains the same pigments and the same vehicle (gum arabic) as watercolor, but with the addition of "body color," which lends opacity. Being opaque, gouache is great for adding intensity to a watercolor painting that needs some extra power and punch.

TO BRIGHTEN THE LIGHTS, INTENSIFY THE SHADOWS

Deeper shadows make nearby light values appear lighter and stronger. You can use this principle when enhancing a watercolor with either gouache or acrylics.

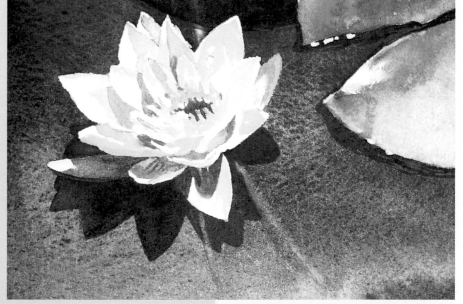

Pond Lily
Gouache over watercolor on 300-lb. (640gsm) rough paper
5¹/₂" x 7¹/₂" (14cm x 19cm)

1 Decent, But Ho-Hum
This painting, *Pond Lily*, is basically well done, but it lacks dramatic light and shadow. There is a technical problem, also. When I did this painting as a demonstration for a student, I pressed extra hard with my pencil so that my student could clearly see the contour lines. If this painting is to succeed, the obtrusive pencil lines must go.

Gouache, being opaque, is perfect for correcting both of these faults. It can cover pencil lines and add intensity.

2 First Gouache Layers
Using gouache and a no. 4 round, I began adding Azo Yellow mixed with a little Cadmium Orange to all the petals. I carried this yellow over the offending pencil lines.

I mixed a warm neutral from Dioxazine Purple and Cadmium Orange and painted over most of the cast shadows to make them darker.

Over the lily pad, I added a mixture of Azo Yellow with a little Phthalocyanine Green. For the lily pad's shadow, I mixed Dioxazine Purple with a small amount of Phthalocyanine Green. I also added a dark value behind the flower and to its upper edge to pop the flower out.

I repainted the center of the lily with a mixture of Pyrrol Red and Cadmium Orange.

To sweep the eye up toward the lily, I lifted some of the transparent watercolor with a stiff nylon flat to suggest an underwater stem.

3 More Intense Shadows and Details
I darkened the shadow areas within the petals by adding varying mixtures of Azo Yellow and Cadmium Orange slightly neutralized with small amounts of Dioxazine Purple. Finally, I lifted one more subtle underwater stem with a stiff nylon flat.

117

Don't Be Afraid to Redo a Painting

When you aren't quite satisfied with a painting and when altering the original painting would be impractical, redoing it entirely makes sense. Perhaps you can improve your technique or try a composition that better communicates your feelings about the subject, as I did in this demontration. You may be pleasantly surprised with the results.

MATERIALS LIST

WATERCOLORS
Cadmium Yellow ✳ Cobalt Blue ✳ Manganese Blue ✳ New Gamboge ✳ Quinacridone Rose ✳ Rose Dore ✳ Ultramarine Blue ✳ Winsor Red

PAPER
Yupo, 23" x 33" (58cm x 84cm)

BRUSHES
³/₄-inch (19mm) and 2-inch (51mm) flat ✳ Nos. 6 and 12 round

OTHER MATERIALS
Facial tissue for lifting paint ✳ Paper towels ✳ Isopropyl alcohol

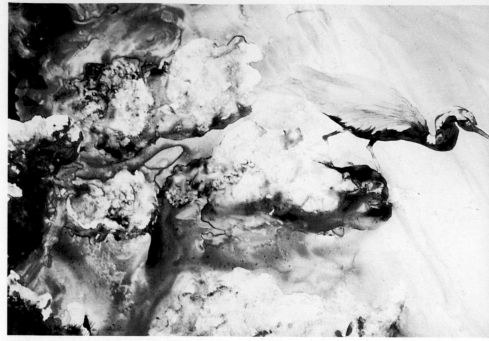

Original Painting
This painting of a little blue heron fishing from the rocks hangs in my sister's living room. The light and shadows create drama, which I like, but the bird's beak is slightly too long. To change the beak on the original painting would risk ruining the smooth wash behind it. I also would like more emphasis on the heron and more movement in the heron's body.

1 Paint the Water

Clean the Yupo with rubbing alcohol as described on page 80. Premix three large puddles of Ultramarine Blue, Cobalt Blue and Manganese Blue on your palette. Use a 2-inch (51mm) flat to apply a wash of Manganese Blue diagonally from the upper right to the lower left. As you work toward the lower left corner, add Cobalt Blue, then some Ultramarine Blue and finally a small amount of Quinacridone Rose to tilt the blue toward a violet. Allow all of this to dry completely.

2 Lift the Rock Shapes

Decide on the placement of the rocks. This time around, they will not take up as much of the picture space as they did in the original painting, making them secondary in importance to the heron.

Use a 2-inch (51mm) flat and plain water to reactivate the pigment in the rock shapes. Lift out the rocks with a crumpled tissue, leaving behind a suggestion of rock texture.

3 Paint the Rocks

Now add puddles of New Gamboge, Rose Dore, Ultramarine Blue, Manganese Blue and Cadmium Yellow to the rocks. Let the colors run together to create texture (nudge them along with a 3/4-inch [19mm] flat). Add more Ultramarine Blue and Quinacridone Rose to the lower rock. The light hits here, so leave some of the surfaces light. To the upper rock on which the heron will stand, add a light-value Cadmium Yellow mixed with New Gamboge and Manganese Blue. Leave parts of the top edge of this rock light where sunlight hits. There should be a difference in color temperature between the lower rock, which is in shadow and therefore cool, and the upper rock, which is sunlit and warmer.

4 Lift the Bird's Silhouette

Using a no. 6 round that comes to a fine point, "draw" the shape of the heron by applying clear water and lifting paint with a tissue. Your goal is to create a white shape that you can work color back into.

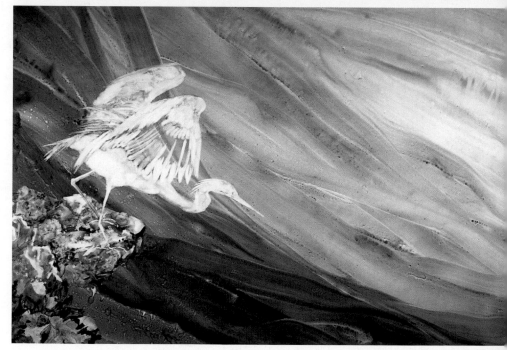

120

5 Paint the Bird

A little blue heron is pure white as a juvenile, but as it matures, it turns a dusky, neutral blue-gray. The adult has a bright blue patch on its upper beak. To achieve the warm and cool neutrals necessary to depict this bird's plumage, mix puddles of Manganese Blue, Quinacridone Rose and New Gamboge. By varying the amounts of these primary colors, you can create beautiful warm and cool grays. Use slightly more Quinacridone Rose in the mix for the tops of the wings and slightly more Manganese Blue and Ultramarine Blue for shadowed areas of the wing. Use Ultramarine Blue and Quinacridone Rose almost straight from the tube for the very dark areas on the head and neck as well as for the shadows between feathers and the shadow side of the legs. To finish the bird, lift a small white highlight from the eye. Add a spot of pure Manganese Blue to the beak. Allow this to dry completely.

6 Finish

Give a quick indication of the bird's reflection using a mix of Manganese Blue and a little Cadmium Yellow applied with a no. 12 round. The more distorted the reflection, the more the water will appear to be moving. Try to execute this reflection quickly so it doesn't look too labored.

Heron on the Rocks
Watercolor on Yupo
23" x 33" (58cm x 84cm)
Collection of Warmels & Comstock, PLLC

Why Do These Paintings Work?

Viewing other people's paintings is, to me, one of the most fun activities in the world. What message did the artist intend to convey? What kind of personality did it take to produce that work? Why and how does this painting make me feel a certain way?

For each of the following paintings I've provided my reaction followed by what each artist has to say. Our views don't always match, but that's part of the fun of creating and appreciating art.

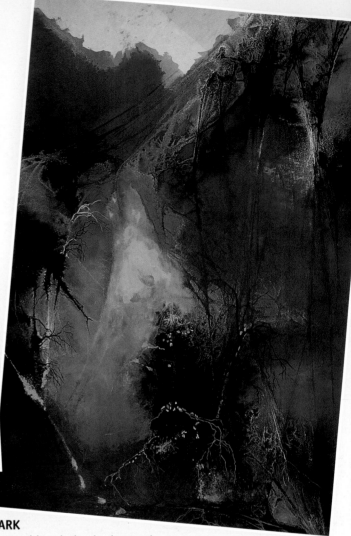

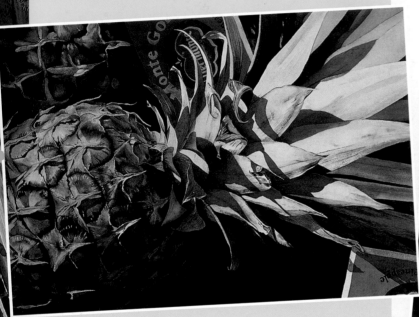

MARK Beth is a delight. Her work matches her personality: lots of light, a positive approach, sureness and sensitivity. *Full Monte* is a feast for the eye. The dramatic light and shadow create a visual platform for the viewer to explore the entire composition. A whole new world is available to those who look just a little closer at seemingly ordinary objects. Beth has brought that vision to life.

THE ARTIST For several years I worked on a series of paintings of slightly larger-than-life fruits and vegetables. To shake things up a bit, I decided to go four times bigger than life to a full-size sheet of watercolor paper. Thus *Full Monte* was instantly named.

I wanted a dynamic, directional emphasis with everything pointing to the interesting shadow shapes on the blue-green fronds of the pineapple. I purposely violated various design rules that warn against placing strong elements in far corners and having a centered focal point. I think the secret is to know design rules but to know when those rules can be relaxed or broken.

Full Monte

Beth Patterson, AWS/NWS
Watercolor on 300-lb. (640gsm) cold-pressed paper
22" x 30" (56cm x 76cm)

MARK

To me, this painting is about color—
unabashed use of full-strength color. The intense warm reds immediately draw my eye, and the edges of the largest shapes move my eye around and through the painting. The balance of dark, medium and light values is superb. There is just enough cool color to act as a foil for all that powerful, warm red.

THE ARTIST I started this painting by clipping my foamboard to a heavy support to prevent warping. I stretched Halloween cobwebs over the surface and then sprayed and brushed several layers of liquid watercolor on the surface. After the paint dried, I removed the cobwebs.

At this point, I began to see the bones of a landscape. I developed the sky and recessed land area with glazing and washes of color: some positive, some negative, some transparent, some opaque. I developed the details of the foliage with calligraphic marks. This landscape is a collective memory of many places I have experienced in my travels.

Beyond Here

Mary Ann Beckwith, NWS
Watercolor on acid-free rag foamboard
40" x 30" (102m x 76cm)

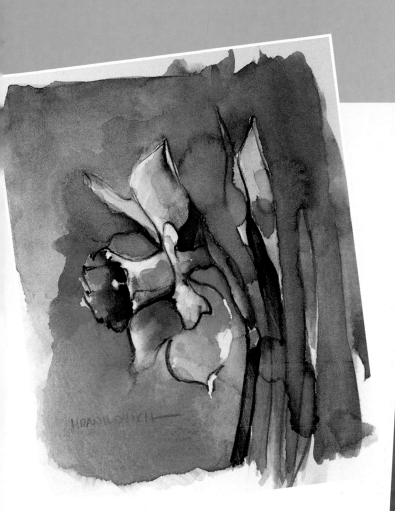

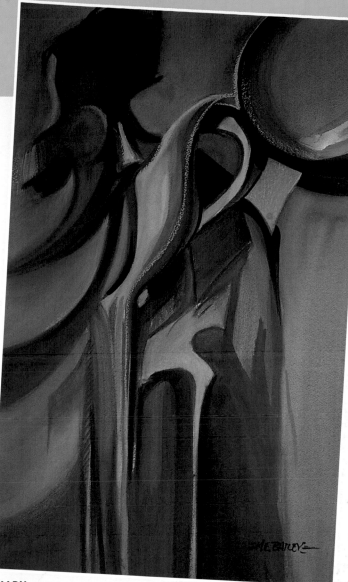

MARK Barb is a commercial and fine artist and makes her living doing both with equal aplomb. Her medium of choice is gouache. *Daffodil* is essentially a portrait. Barb has lifted an ordinary flower, a daffodil, to something extraordinary. Her use of neutralized color and overlapping layers gives a subtlety to the painting that invites the viewer to explore more deeply. The intense, saturated pigment in the bloom has extra punch because it is surrounded by neutrals. The vignette places an importance on this flower; perhaps it is a metaphor for our lives, our growth, our yearnings.

THE ARTIST I'm drawn to nature images because they allow me to feel like I do when looking at plants in my garden. This image is fleeting, spontaneous—more of an impression than a record. By moving in close to a small subject, I made it seem precious yet grand. Separated from its context, the daffodil can read as a simple sculptural object. I believe this piece captures the delicacy and character of a daffodil. It has attitude.

Daffodil
Barb Hranilovitch
Gouache on 140-lb. (300gsm) hot-pressed paper
12" x 9" (30cm x 23cm)

MARK
This painting is all about mood. As I view it, I bring my limited but enthusiastic knowledge of the music we call the blues. Life's curves, the hardships we all endure, and the decisions we make and live with are all communicated by both the music and this painting. Mike has brought this mood to the viewer with his use of an analogous color scheme and a low-key approach. The curvilinear forms suggest the possibility of a horn player with a subtlety that approaches abstraction. That really gets me involved in the work.

THE ARTIST This painting is based on the feeling of blues music and jazz. It was born out of a series of over forty paintings around that theme. In each one I distorted the design elements and found new areas to refine or change. This painting came about when I changed shapes and color. I built rhythm and flow by merging shapes and using dark line to emphasize some edges. By choosing an analogous color scheme, I was able to push the color temperatures and values to deliver an unmistakable color statement of blues. I also painted this piece vertically, letting the natural flow of paint down the sheet help select some of the space divisions, which added to the fun of painting the piece.

Da Blooz
Michael Bailey
Watercolor on 300-lb. (640gsm) rough paper
30" x 22" (76cm x 56cm)

123

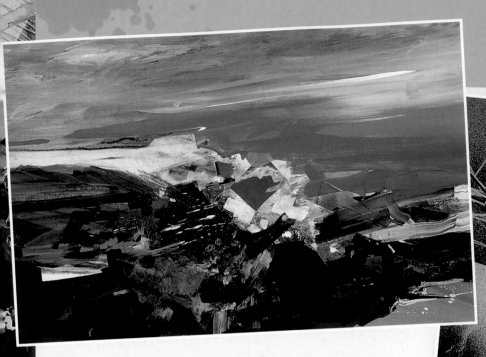

MARK This painting is a well-organized piece that avoids being static and dull. There are essentially three major shapes: a large midtone, a smaller dark and an even smaller light. The shapes are arranged in horizontal bands. The variations of value and hue suggest sky, land and water. This painting works both as an abstraction and as a representational, impressionistic piece.

THE ARTIST I painted this after taking a hike in the North Carolina mountains. I had stood on the edge of a cliff, where, as the title suggests, the scene was breathtaking. The quietness of the sky created a sense of space and distance. I painted the edge of the cliff as a straight line to suggest the land ascending to the cliff edge. The actual cliff was not busy, but I needed the rugged rocks and sharp edges in my painting for contrast. I added bold color in the rocks for excitement and impact. I hope viewers of this painting feel as if they are invited into the image to walk out to the edge of the cliff.

Take a Deep Breath
Mary Alice Braukman, NWS
Watercolor, mixed media and collage on Saunders Waterford cold-pressed paper
22" x 30" (56cm x 76cm)

MARK This painting is a wonderful blending of high-contrast shapes and a limited palette. Value separations, texture and the placement of the largest shapes are what make this painting effective.

THE ARTIST While teaching a workshop at an art supply store, I saw boxes of scrap papers that I couldn't wait to get my hands on. The window of the store's workshop area faced a great vista with trees, and I immediately thought of birches. I placed strips of paper randomly on my watercolor paper and sprayed away with a mouth atomizer. Most of this painting was done very quickly as a demonstration. Back in my studio, I added a square piece of paper, some painted collage strips and a very transparent loose wash. This study was part of my ongoing search to discover the essence of birch.

Birch Essence, 2
Pat Dews, AWS/NWS
Watercolor, mixed watermedia and collage on 140-lb. (300gsm) cold-pressed paper
26" x 22" (66cm x 56cm)

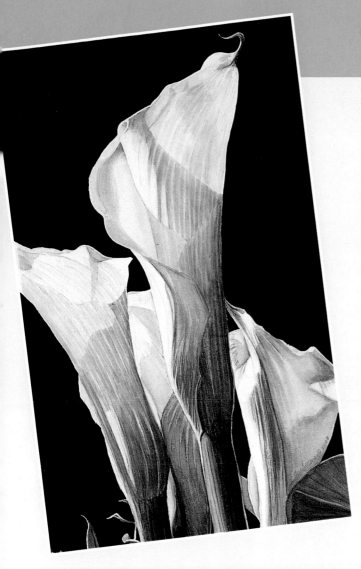

MARK This striking painting is about light, shadow, form and some presence larger than simple calla lilies. Bev uses the shapes and forms of the lilies to give us a visual story that transcends mere reporting. Her use of dark, quiet areas that contrast with the light-filled positive forms draws the viewer into her world. The work has a powerful visual impact that stops viewers in their tracks, something every painter should wish for!

THE ARTIST This grouping of calla lilies grabs the viewer's attention with stark, dramatic contrasts between the delicate white lilies and a deep black background. The painting succeeds not only because of its simple, direct design but because of the use of textures and contrasts. The white lilies are painted in transparent watercolor with a hint of gesso. They contrast strongly with the heavily spattered, Lamp Black gouache background. If the background were gray or a medium value, the painting would lose its "Hey, look at me!" attitude.

The Gathering
Beverly Leesman
Watercolor, gesso and gouache on 300-lb. (640gsm) cold-pressed paper
17" x 10" (43cm x 25cm)

MARK Donna is a very thoughtful and contemplative artist. She makes powerful paintings that can be explored on many levels. Why has this group of people gathered? Why are they seated as they are? What is the relationship between the man with the crutch and the children to his left? Moreover, Donna has done a marvelous job of showing us the light. The small lights lead the eye through the painting. The use of the complements blue and orange makes the eye dance around and through the composition.

THE ARTIST It seems to me that life, like art, is all about connections, contrasts, relationships and balance. I snapped the reference photo at Pier 39 in San Francisco. The people were resting or waiting for the folks they were shopping with. As I worked on the painting, the people came to represent Everyman to me: young and old, man and woman, happy and sad, healthy and sick, together and separate—we're all there. It also brought to mind the various stages of life. With these ideas in mind, I emphasized body language and created a design of contrasting light and shadow patterns to connect all elements in the composition.

Lifestories
Donna Zagotta, AWS/NWS
Watercolor, gouache and crayon on 300-lb. (640gsm) hot-pressed paper
30" x 22" (76cm x 56cm)

125

Conclusion

When I conduct one of my week-long painting workshops, I tell the artists in attendance that I'm going to give them many lessons and many pieces of information—too many, in fact. A workshop is a busy, lively, fun-filled week; no student could possibly assimilate and use everything we try. Moreover, not every idea presented will work for every student. A workshop is a time to experiment with unfamiliar concepts and techniques, and it may take time for something discussed, practiced or produced in a workshop to become relevant to a student's work.

The same goes for this book. It's packed with material, some of which will work for you right away, some of which may become relevant to you later or not at all. But if even one small piece of information—a discussion of content, a lesson on design or a demonstration of technique—helps you along the journey of painting, then the effort I put into this book will have been worthwhile.

Thank you for participating in this *Creative Watercolor Workshop*!

—Mark E. Mehaffey

Index

NORTH LIGHT BOOKS

Learn to paint stunning watercolor with these other fine North Light Books!

Celebrate Your Creative Self
by Mary Todd Beam
ISBN 1-58180-102-5, concealed spiral,
144 pages, #31790-K

One of the best-known workshop instructors in the realm of artistic creativity, Mary guides you into uncharted territory through 25 creative demonstrations covering light, color, texture, design and more. You'll discover fresh materials, new techniques and unexpected jumpstarts for your creativity.

The Watercolorist's Essential Notebook
by Gordon MacKenzie
ISBN 0-89134-946-4, hardcover,
144 pages, #31443-K

20 years of painting experience in one notebook! This book focuses on the things that make a difference in your painting—the best paints to use, 3 no-fail approaches to composition, and much more. Lots of illustrations and step-by-step demonstrations make key concepts and techniques fun to learn and easy to grasp.

The Watercolorist's Answer Book
Edited by Gina Rath
ISBN 1-58180-633-7, paperback,
192 pages, #33208-K

This is the authoritative guide to the art of watercolor featuring the combined expertise of eight successful professional artists. With 425 popular tips, techniques and solutions selected from North Light's best watercolor instruction books and 20 step-by-step demonstrations, every watercolor painter, beginning or advanced, will benefit from this book.

Watercolor Wisdom
by Jo Taylor, AWS
ISBN 1-58180-240-4, hardcover,
176 pages, #32018-K

This classic book on watercolor painting emphasizes the principles of design. From time-tested color harmonies to a step-by-step approach to developing powerful compositions, this book fuses technique, style and design—the keys to great painting.